Postcard History Series

Evanston

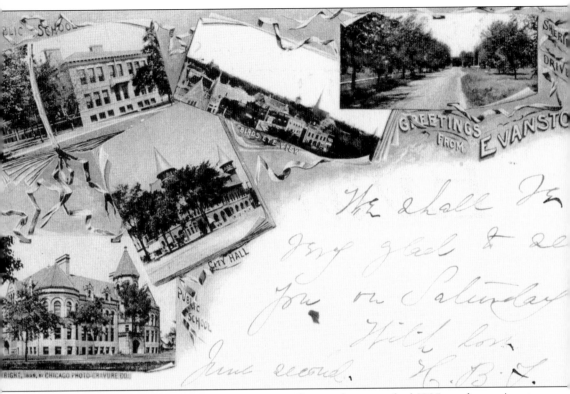

GREETINGS FROM EVANSTON. This private mailing card, postmarked 1905, sends greetings to the recipient and is showing a bird's-eye view of Evanston, two public schools on the left (lower left is Central School), city hall in the center, and Sheridan Drive (top right) in Evanston.

On the front cover: **SHERMAN AVENUE.** Fountain Square, along with city hall, can be seen in the distance behind the streetcar that is shown headed north down Sherman Avenue. The post office, designed by James Knox Taylor (1857–1929) and completed in 1906, was located on the southwest corner of Sherman Avenue and Church Street, the present site of the Barnes and Noble Booksellers at Sherman Plaza. The post office remained at that location until 1939, when it was razed, and the S. S. Kresge Store was built on the site. This postcard was postmarked 1908. (HCL.)

On the back cover: **GROSSE POINT LIGHTHOUSE.** In 1871, Congress appropriated $35,000 to construct a lighthouse on the bluff recognized by early Native American settlers as the "Eyebrow of Beauty." Later French explorers deemed the area Grosse Pointe. The 113-foot tower was built on a stone base 25 feet in diameter. The light, seen here in this card postmarked 1915, is the last remaining second-order Fresnel lens on Lake Michigan. Although officially decommissioned by the U. S. Coast Guard in 1935, the light still operates today, continuing to guide boats to nearby Chicago. (VOH.)

Evanston

To Leslie,

Best Regards,

Mimi Peterson

Mimi Peterson

ARCADIA
PUBLISHING

Published by Arcadia Publishing
Charleston SC, Chicago IL, Portsmouth NH, San Francisco CA

Printed in the United States of America

Library of Congress Catalog Card Number: 2007939986

For all general information contact Arcadia Publishing at:
Telephone 843-853-2070
Fax 843-853-0044
E-mail sales@arcadiapublishing.com
For customer service and orders:
Toll-Free 1-888-313-2665

Visit us on the Internet at www.arcadiapublishing.com

*This book is dedicated to all those who cherish the charm
and character of Evanston's past. I want to thank my family and friends,
with special thanks to my good friend Judy Jager, and to Lori Osborne of the
Evanston History Center.*

CONTENTS

ACKNOWLEDGMENTS

Dates and publishers have been provided with each postcard image when available. Generally the postmark date is incorporated in the caption, but when the publication year for a postcard is known that has been included in the caption title. The contributors and their abbreviations are as follows:

the Acmegraph Company, Chicago (A)
the Albertype Company, Brooklyn (AC)
American Colortype, Chicago (AC2)
A. J. Schumann, Chicago (AJS)
Albert M. Wilson, Buffalo (AMW)
B. S. Reynolds, Washington, D.C. (BSR)
C. M. Morris (CMM)
Chicago Photo Gravure Company (CPG)
Charles R. Childs, Chicago (CRC)
Curt Teich and Company, Chicago (CT)
E. B. Heimstreet (EBH)
E. C. Kropf Company, Milwaukee (ECK)
F. A. Owen Publishing Company, Dansville, New York (FAO)
F. Gairing and Company, Chicago (FG)
Gavure Company, Evanston (G)
Grogan Photo, Danville, Illinois (GP)
Houston Art Print, Cincinnati (HAP)
H. E. Chandler and Company, Evanston (HEC)
Hugh C. Leighton Company, Portland, Maine (HCL)
International Postal Card Company, Chicago (IPC)
John Willy, Inc., Evanston (JWI)
J. O. Stoll Company, Chicago (JOS)
L. F. Pease, Buffalo (LFP)
L. L. Cook Company, Milwaukee (LLC)
Max Rigot Selling Company, Chicago (MRS)
Mid-West Map Company, Aurora, MS (MWM)
P. L. Huckins, Chicago (PLH)
Paul R. Vogel Company, Chicago (PRV)
Rotograph Company, New York City (RC)
Ralph Tuck and Sons (RTS)
S. H. Knox and Company, Chicago and Leipzig (SHK)
Suhling Company, Chicago (S)
Simplicity Company, Grand Rapids, Michigan (SC)
Tom Jones, Cincinnati (TJ)
Valentine and Sons Publishing Company, New York (V)
V. O. Hammon Publishing Company, Chicago and Minneapolis (VOH)
Wesley Bowman (WB)
William S. Lord, Evanston (WSL)

INTRODUCTION

The history of Evanston begins before the town was incorporated in 1863. In 1673, Fr. Jacques Marquette and Louis Jolliet discovered Potawatomi Indians living on the western shore of Lake Michigan. This area had long been known to fur traders as Grosse Pointe. In the late 1820s, immigrants began arriving from Germany, Ireland, New England, and other eastern states. The first white settler, Stephen J. Scott, had a problem acquiring land along the swampy grounds in 1826 because the United States government had yet to arrive at negotiations with the local Native Americans. Scott located his cabin in an area overlooking Lake Michigan (the low bluff) covering the area west to the ridge.

Since Colonial days an important North American economic activity was the profitable fur trade. A trading post had been established in 1803 at Fort Dearborn in Chicago. By 1829, the federal government reached an agreement, the Treaty of Prairie du Chien, with the Chippewa, Ottawa, and Potawatomi Indians. Another contribution to the rapid settlement of this area was the connection of the Illinois and Michigan Canal with the Mississippi River system in 1848. Understandably, land speculation was very high.

Maj. Edward H. Mulford (1794–1878) came to the frontier town in 1835. For $60, he purchased a tract of land north of the Indian Boundary Line along (old) Green Bay Road, currently Ridge Avenue, between what would become Oakton and Howard Streets in modern-day Evanston. In order to ensure his claim, he built a simple log cabin near the current site of St. Francis Hospital. Later he purchased more land and built a tavern across the street from the cabin, which was known as Ten-Mile House. Major Mulford was the first justice of the peace in Cook County, and the tavern often served as a courthouse. In addition, in 1846, the final e's were dropped from Grosse Pointe and the tavern also became known as the first post office. At this time, mail arrived just once a week via stagecoach. The first postmaster was George M. Huntoon (1815–1879).

Known for his jovial disposition and love of a good time, William F. Foster, also known as "Uncle Billy" Foster, was the life of many "raisings," as cabin building was called then. Foster, a native of Ireland, brought his wife and six children to Ridgeville on a houseboat from New York in 1838 and built his house on the ridge near Grant Street in 1841–1843. An Evanston landmark, the house was moved in 1922, just west of Ridge Avenue to 1016 Colfax Street where it remains today. Foster was one of a party of gold seekers who went to California in 1850. He returned with enough fortune to fuel his endeavors in lumber and house moving.

In 1848, the post office was moved to the Buck-Eye Hotel and Tavern, another stagecoach stop and hotel along the (old) Green Bay trail. The Buck-Eye Hotel and Tavern, also known as the Thirteen-Mile House, was built by Isaac Burroughs (1824–1867), an Ohio native. The tavern was located on the east side of the ridge, just north of Noyes Street, later known as 2241 Ridge Avenue, where currently an apartment building is located. The Buck-Eye Tavern was moved in 1916 to 1204 Noyes Street, where a part of the old building was incorporated and still stands. By April 1850, the town had grown to a population of 343, and there were enough settlers to form a township, which was named Ridgeville. David Warner Burroughs (1817–1901) was appointed postmaster in 1849. The name of the post office was changed again to Ridgeville.

The Northwest Territory, at that time limited to Illinois, northern Indiana, Iowa, Michigan, and Wisconsin, was without a school for higher education. A small group of Methodist men, determined to build a place of "sanctified learning," gathered in May 1850 in a Chicago law office.

They drafted a charter "to incorporate a literary university under the control and patronage of the Methodist Episcopal Church." Chiefly through the efforts of young attorney Grant Goodrich, the charter became law by act of the Illinois legislature on January 28, 1851. Orrington Lunt is credited for his determination to locate Northwestern University at the lakefront location in Ridgeville. Dr. Clark Titus Hinman (1819–1854), who represented the Michigan Methodist Episcopal Conference, died of typhoid fever before he was able to serve as the university's first elected president.

During 1853–1854, Philo Judson (1807–1876) saw to the accumulation and platting of the Foster and Carney farms. Judson submitted the plat of Evanston, named in honor of Dr. John Evans (1814–1897) on July 27, 1854. An amendment (drafted by Evans) to the university's charter was added on February 14, 1855, which provided that

> no spirituous, vinous, or fermented liquors shall be sold under license, or otherwise, within four miles of the location of said University . . . [and] that all property of whatever kind or description, belonging to or owned by said corporation, shall be forever free from taxation for any and all purposes.

These two provisions characterized Evanston and the university for many years and to some extent still do. With the repeal of Prohibition in 1933, Evanston voted in 1934 to maintain the four-mile limit until 1972, when the city council allowed liquor by the glass to be sold. Finally in 1984, Evanston issued the first packaged liquor sales license to John Hamel at 1019 Davis Street. However, the tax-exempt status of the university remains in perpetuity.

The state legislature officially changed the name of Ridgeville to Evanston on February 15, 1857. One year later, Josiah F. Willard (1805–1868), a devout Methodist from Janesville, Wisconsin, enrolled his two daughters Frances and Mary in the North Western Female College in Evanston. Frances E. Willard (1839–1898), a woman ahead of her time, was soon to become a world-renowned temperance and women's rights advocate.

In the 1860s, the population in Evanston was 831. Soon Evanstonians would rally to serve the Union in the Civil War. Constantly reminded of the sanctity of the alcohol-free four-mile limit, on December 29, 1863, forty-seven residents gathered at the Reynolds House to vote on whether or not Evanston should incorporate as a town. The thought was that if Evanston were incorporated, it could better exercise the four-mile limit. The results of the election were 8 opposed and 39 in favor of the proposal. As a result, on January 6, 1864, Harvey B. Hurd (1828–1906) was elected to serve as the first president of the town by trustees Charles Comstock, Edwin Haskin (1817–1904), Henry Sanborn Noyes, and John Clough.

As a result of the Chicago fire in 1871, many more people would come north to make Evanston their home. Its per capita wealth ranked it first among Chicago's high-status suburbs. The area of present-day Evanston then had 3,062 residents and three governments. The Town of Evanston reorganized as a village in 1872. North Evanston was organized as a village in 1873 and annexed by Evanston one year later. South Evanston, however, organized as a village in 1873 and remained independent for 19 years. After much debate, a referendum to annex South Evanston to Evanston was held on February 20, 1892, and finally approved by voters. On election night, a bonfire was lit in Fountain Square to celebrate. Therefore, on March 29, 1892, the City of Evanston was incorporated, with Dr. Oscar H. Mann (1834–1911) elected shortly thereafter as its first mayor.

One

POSTCARD HISTORY

The first postcard printed with the intention for use as a souvenir was placed on sale at the Columbian Exposition in Chicago in 1893. Only the U.S. government was allowed to print postcards until May 19, 1898, when Congress passed the Private Mailing Card Act, which allowed private firms to produce postcards. The private mailing card cost 1¢ to mail, and the term "private mailing card" was required to be printed on cards that were not printed by the U.S. government. The earliest cards shown in this collection are from this era, and so the chapter begins with assorted types of greeting cards that depict early images of Evanston. The images will be detailed individually later in the book.

Most postcards from 1901 through 1907 are printed on an undivided back, meaning no line down the middle. Writing was not permitted on the back side, which was reserved for the address only. Finally, beginning in 1907, the backs of cards could be used for both messages and address, creating the divided-back cards now seen, leaving the front for art or pictures. The address had to be written on the right side of the back of the postcard while the left side was reserved for writing messages. Postcards from this period are most collectible when they do not have writing on their front side. This marks the beginning of the golden age of postcard collecting (1907–1915). At this time in American history, the postcard hobby became a public addiction. Publishers printed millions of cards in this era. Most postcards were printed in Germany, the world leader in lithographic processes. At the height of the countrywide mania, World War I caused a crash in the hobby. The war caused the supply of postcards from Germany to end. Poorer quality postcards came from English and U. S. publishers. The lowered quality of the printed postcard, recurrent influenza epidemics, and World War I war shortages killed the American postcard hobby. During the war years, the telephone replaced the postcard as a fast, reliable means to keep in touch.

PRIVATE MAILING CARD, 1899. This card is an example of the front side of a private mailing card, written on by the sender in 1905. On one of the earliest greetings-style cards, the sender writes, "We let time pass by, but every moment is recorded." Evanston was already proud, boasting a "business block" (Rood Building), lower left; a public square, center left; two railroad depots, center and top left; a U. S. Coast Guard station, center top; and a "Landmark on Davis," by then known as the Avenue House, top right. Postmarked 1903, the lower card sends New Year's greetings showing the observatory, library, and University and Memorial Halls. (G.)

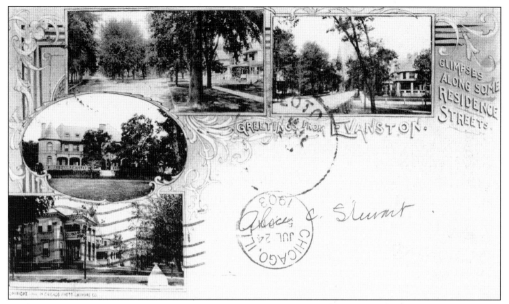

GLIMPSES OF RESIDENTIAL STREETS. The front of this private mailing card shows pretty details along with the postmark from 1903. The sender is showing off Orrington Avenue and University Place, top left; Hinman Avenue looking north, top right; and two residences, lower left. (CPG.)

BACK SIDE OF PRIVATE MAILING CARD. This private mailing card shows the Benjamin Franklin 1¢ stamp cancelled in Evanston in 1903. The card is a fine example of the Congressional authorization stamp and the "exclusive for address" statement that was required to be printed on cards at that time. (CPG.)

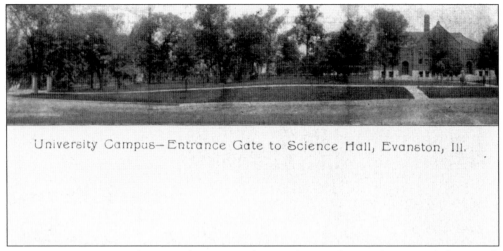

University Campus—Entrance Gate to Science Hall, Evanston, Ill.

UNIVERSITY CAMPUS. This unused private mailing card, around 1890, shows a real photograph of Northwestern University's Fayerweather Hall (dedicated in 1887), shown along what was then University Place at the northern dead end of Hinman Avenue. Designed by Holabird and Roche, the building was demolished in 1954.

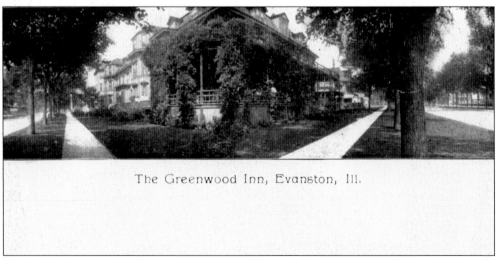

The Greenwood Inn, Evanston, Ill.

GREENWOOD INN. Another unused early card with an undivided back shows the Greenwood Inn. Located at Greenwood Street (right) and Hinman Avenue, the name provides a clue as to the date. The three-story double house was sold by Orvis French (1822–1897) to Benjamin Bayless (1844–1920) in 1896, and it was renamed the Greenwood Inn.

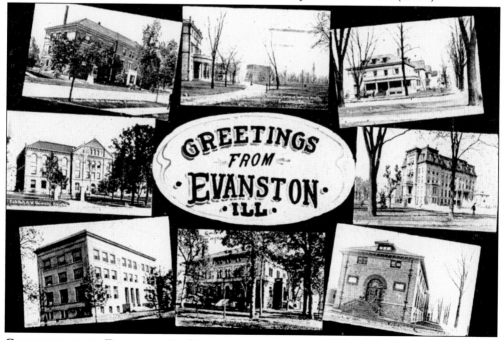

EVANSTON COUNTRY CLUB. Situated on the northeast corner of Oak Avenue and Lake Street, the Evanston Country Club opened with a gala ball on October 18, 1892. The two-story frame structure, 65 feet by 85 feet and designed by Holabird and Roche, was engulfed in flames and burned completely on December 16, 1922. This card is postmarked 1906. (WSL.)

GREETINGS FROM EVANSTON. In this greetings card, postmarked 1910, individual photographs show university buildings Chapin Hall, Orrington Lunt library (dedicated in 1894), Pearsons Hall, Fisk Hall, Willard Hall (completed in 1874), the School of Oratory, and the School of Music (dedicated in 1897). (FG.)

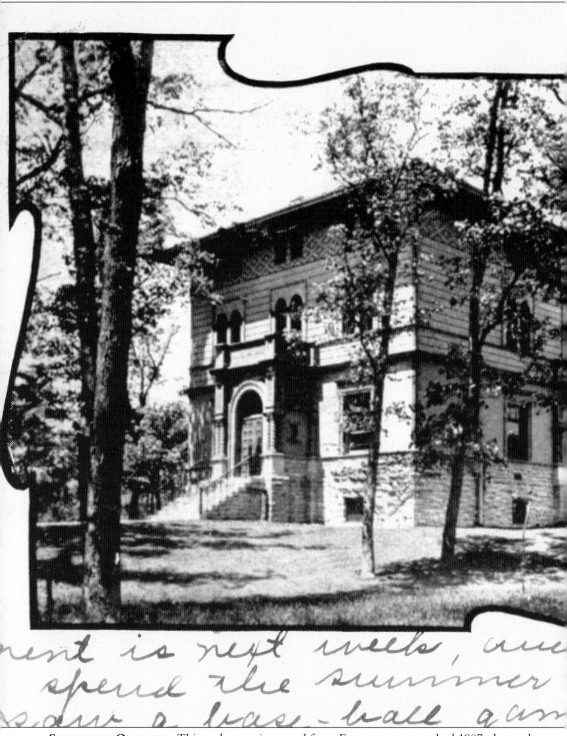

SCHOOL OF ORATORY. This early greetings card from Evanston, postmarked 1907, shows the Cumnock School of Oratory, also known as Northwestern University's Annie May Swift Hall or the School of Communication. Note that the writing is on the front of the card and the sender

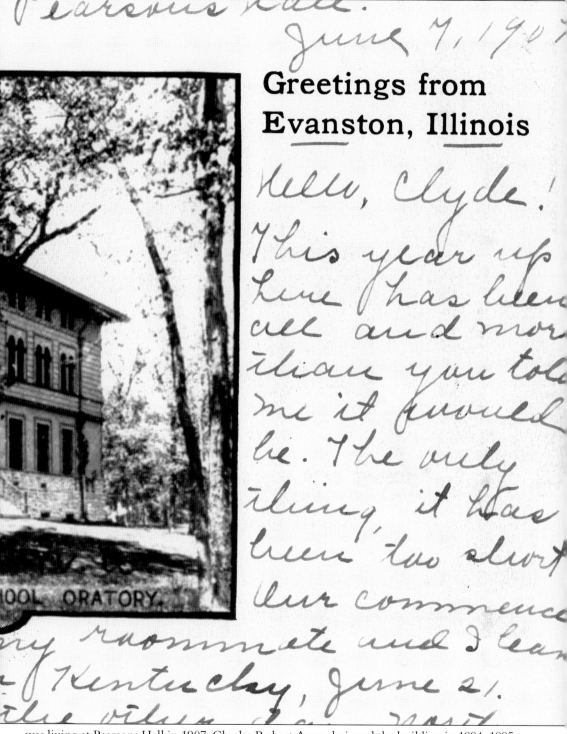

was living at Pearsons Hall in 1907. Charles Robert Ayars designed the building in 1894–1895, and today it is preserved as a historic landmark.

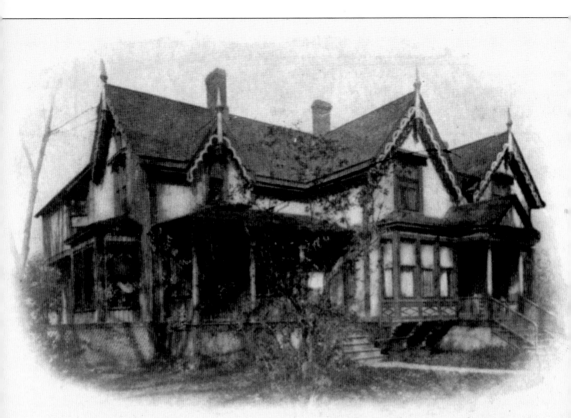

Rest Cottage
Home of Frances E. Willard

The Willard
Headquarters of the National W. C. T.
Evanston, Ill.

FRANCES E. WILLARD REST COTTAGE, C. 1907. Rest Cottage was the home and office of Frances E. Willard (1839–1898), known worldwide for her leadership in temperance and women's suffrage. In 1878, after the death of Frances E. Willard's brother Oliver, an eight-room addition was built on the north side of the house for his widow, Mary Bannister Willard, and her four children. The bay and second entrance porch ties the addition to the original building. Mary moved to Germany, and in 1901, Frances E. Willard's home became a museum and the headquarters of the National Woman's Christian Temperance Union. Built in 1865 by Josiah Willard, the Victorian Gothic house is still located at 1730 Chicago Avenue.

Two

Transportation

Public transportation was very important to the growth of Evanston. The Chicago and Galena Union Railroad was the first to develop a road or a line for a railroad in Illinois, and the first train to pass through Evanston was in 1854. Soon it would be bought out and become the Chicago and North Western Rail Road. On February 10, 1855, the Chicago and Milwaukee Railroad stopped in newly laid-out towns, including Evanston, all the way to Waukegan. One of the first engines to come through Evanston was the *Pioneer*, which can be seen at the Chicago Field Museum. The new railroad helped to determine the location of the business section of town and brought more people to the area. At this time there were no sidewalks or streetlights, and those who came home in the evening usually left a lantern at the station in the morning.

In the early years, until 1882, the trains operated on a single track, having to avoid collision. Service was not frequent, there was but one train running twice daily to Chicago. A meeting was held to consider continuing service on the north suburban route. One man in attendance suggested that more and better service be provided, predicting that the suburban line would one day become the most heavily used in the area. By 1874, the fare from Chicago to Evanston was 14¢ for a 100-ride ticket. Excluding Chicago, today Evanston's Transportation Center, built in 1993, is the only location in northeastern Illinois that offers four types of regional transportation.

Beginning in the 1880s, talk began of elevated, electrified trains that would offer quick transit between Evanston and Chicago. There were plans for trains that ran every 15 minutes with stations every two blocks. What ultimately came to pass in 1886 was steam service provided by the Evanston Division of the Milwaukee Road. A franchise was originally granted to the Chicago Evanston and Lake Superior Railroad, which was quickly purchased by the Chicago Milwaukee and St. Paul Railroad, and would eventually become today's Chicago Transit Authority. The company began operating 13 trains on a route parallel to the Chicago and North Western line from Evanston to Chicago. The line extended south into Wilmette in 1889. Elevated trains would not come to Evanston until 1911.

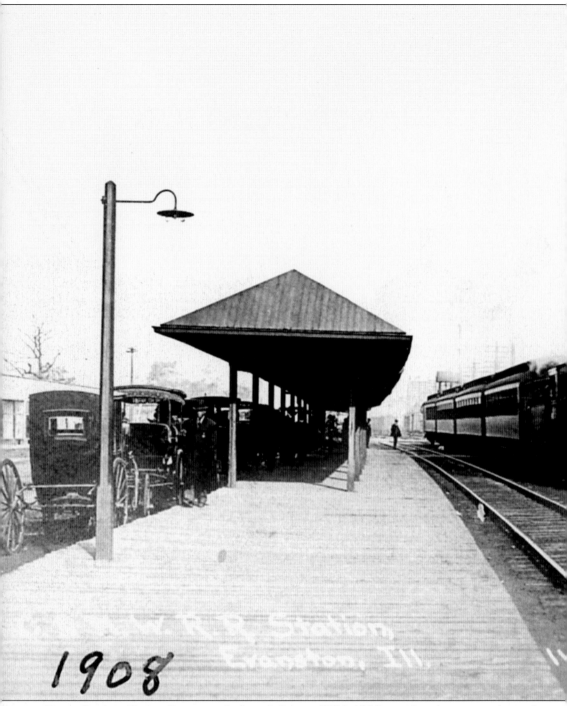

1908

DAVIS STREET TRAIN STATION. Andrew J. Brown (1820–1906), a university trustee, donated the land (formerly the Carney farm) needed for the station and the right-of-way from Davis Street to Church Street. This real-photo card shows a southbound train arriving at the Davis Street Chicago and North Western station. During this time the station and the tracks were still on the ground level, running right through the streets of Evanston. Fountain Square was one

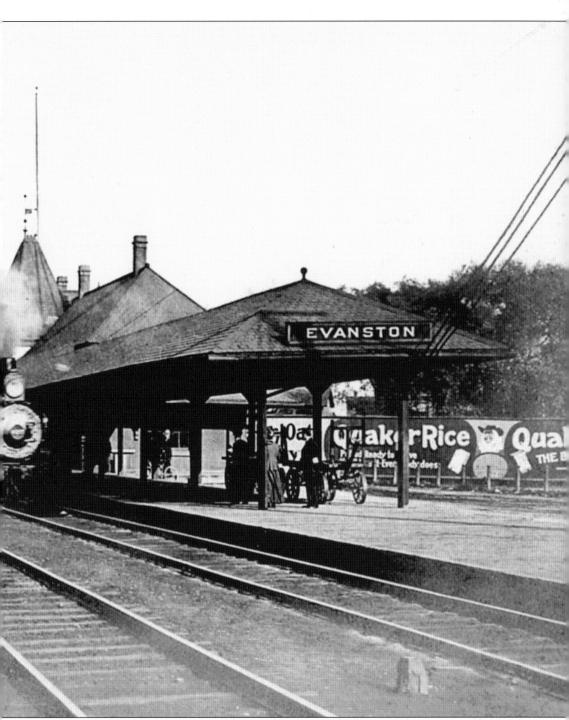

block to the east (right). Carriages of the time can be seen (left) of the Chicago Evanston and Lake Superior Railroad Depot. Today the Evanston sign shown on the station shelter (right) is hanging in the research room of the Evanston History Center. (CRC, courtesy of the Evanston History Center.)

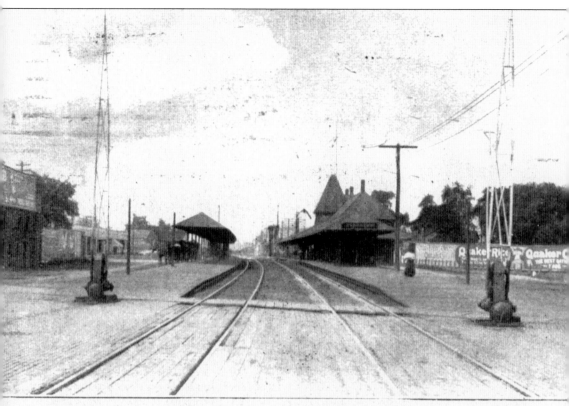

NORTH WESTERN RAIL ROAD DEPOT. The Davis Street passenger depot was designed by Burling and Whitehouse and built north of Davis Street on Benson Avenue in 1886. The old depot was demolished in 1909 after the Chicago Milwaukee and St. Paul Railroad was given permission to run its elevated trains over the Chicago and North Western Rail Road elevated tracks. In this view also looking north at the Davis Street station, street level crossing gates can be seen clearly on the left and right of the photograph. The card, postmarked 1907, has been used, and on a divided back the sender writes, "You may write as often as you please, the postman comes around three times a day now." (IPC.)

4454. Chicago & Northwestern Passenger Depot, Evanston Ill.

DAVIS AND CENTRAL STREET STATIONS, LOOKING SOUTH. In April 1909, the Chicago and North Western Rail Road announced its plans to spend $173,000 to build elevated train stations at Calvary Cemetery, Main Street, Dempster Street, and Davis Street in Evanston. The Central Street station was constructed later. All were built of the same architectural style and could be described as modified Swiss and distinctly ornamental. Each was a two-story structure due to the elevation. At the Davis Street and Main Street stations, the entrance vestibules and interior waiting rooms were on the track level and had art marble floors, with hardwood finish. The completed train stations were open by 1911. Today Chef's Station, a fine restaurant, is located beneath the Davis Street station. In addition to providing transportation, the old Main Street station is also a cultural center known as Evanston Arts Depot, which houses the offices of the Custer's Last Stand festival and has performance space for Piccolo Theatre. (PLH.)

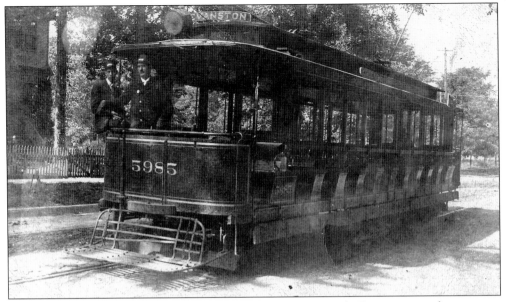

ELECTRIC STREETCARS. Another form of transportation in early Evanston was the streetcar. Facing opposition from residents, and after arduous city council debate in July 1893, the Chicago and North Shore Street Railway Company began operating electric streetcars that connected to cable cars in Chicago at the Wrightwood Avenue barns. The fare was 5¢. Evanston was first to supply electrified streetcars all the way to Emerson Street. (Courtesy of the Evanston History Center.)

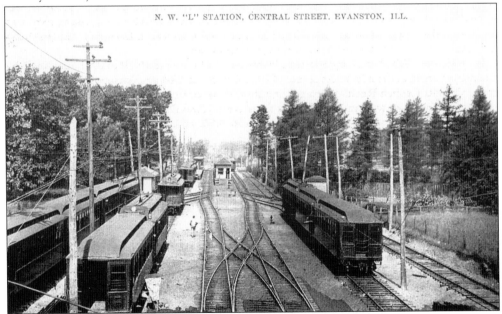

N. W. "L" STATION, CENTRAL STREET, EVANSTON, ILL.

CENTRAL STREET L, c. 1900. Founded as the Bluff City Electric Railway in 1894, the train line grew to become the Chicago and Milwaukee Electric Railway Company. In 1902, the line went all the way to Waukegan and, by 1908, reached Milwaukee. The North Shore Line closed in 1954, and the Chicago Transit Authority took over the property. (Courtesy of the Evanston History Center.)

Three

Downtown Evanston

In the 1920s, Victor Carlson's seven-story buildings were considered Evanston skyscrapers. State National Bank actually built Evanston's first skyscraper in the 1960s. Today Evanston continues to wrestle with issues of how to balance its past with its future.

Early stories say that in 1853, carpenter Philo Purdy Johnson (1835–1899) built the frame building on the northeast corner of Davis Street and Orrington Avenue and operated a general store. Later James B. Colvin, who came to Grosse Pointe in 1836, operated the store and also served as postmaster. The building was moved north of the corner in 1874 and finally moved to 1417 Ashland Avenue in 1897. The brick building built on the corner in 1873, by Charles T. Bartlett, was used by William C. Garwood to operate a pharmacy and soda fountain. Stories have been told for years that this is the location where ice-cream sundaes were first created.

During the 1860s, Edward Eggleston held Sunday school for children in his home. He often allowed them to borrow books from his personal library. It is said that it was his inspiration for a public library to be built, although he left town before the constitution of the Evanston Library Association was adopted on October 18, 1870. The library's first home was at 613 Davis Street on the second floor of a doctor's office.

In Evanston's first directory of 1879, Thomas Clarkson Hoag (1825–1906) advertises as a notary public, fire insurance agent, and a family grocer. In 1857, he moved to Evanston and located his grocery store in Chicago. The Chicago fire destroyed his business, and he reopened in 1874 on the southeast corner of Chicago Avenue and Davis Street. Eventually the first bank in Evanston was run out of the back of Hoag's grocery store.

In 1885, the YMCA was organized in Evanston and located in the Rink Building built by George Jackman, at the northwest corner of Davis Street and Chicago Avenue. By the early 19th century, Viola Crouch Reeling wrote, "In a short space of time an up-to-the-minute city had risen, where once grew swamp grasses and forest trees." And Daniel H. Burnham, an Evanston resident and director of works at the world's fair in 1893, said, "Evanston is the most beautiful city in the world."

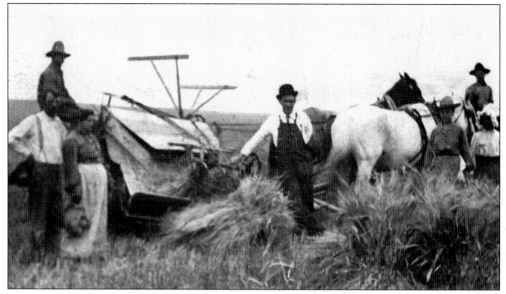

EVANSTON HAY FIELD WORKERS, C. 1880. Depending on the weather, Evanston's business district in 1866 was either a dusty or a muddy street crossed by a large, open ditch used for drainage. Sidewalks were made of wood planks, with only a few stores and houses. Some of the businesses were George Dunoon, draper and tailor; M. F. Haskins, dry goods and notions (later the Enterprise); George W. Muir, bookseller and stationer; and Samuel Harrison, at 604 Davis Street, selling fresh meats. The triangular piece of land at Sherman and Orrington Avenues was used as a wood and hay market. Farmers would come with their loads of hay, wagons or bobsleds would come from the west with their firewood, and lumber would arrive from the Davis Street Pier. Here unbaled hay could be bought by the ton and wood by the cord. There was a trough for watering horses and a flagpole donated by the Daughters of the American Revolution. (G.)

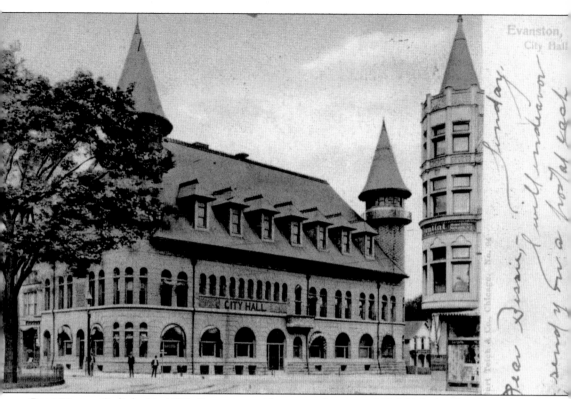

CITY HALL. On July 21, 1891, Evanston residents voted to issue $30,000 in bonds to build a new village hall. The Fountain Square site at the northwest corner of Sherman Avenue and Davis Street was chosen during Oscar H. Mann's (1834–1911) tenure as president of the board of trustees. The building opened in October 1892; the public library, housed on the second floor, opened in May 1893. This postcard is postmarked 1905. (CT.)

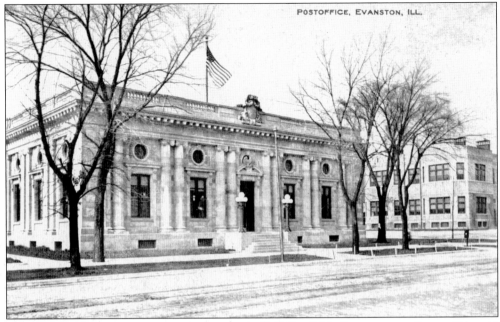

POST OFFICE VIEW ON SHERMAN AVENUE, C. 1908. In 1902, Congressman George Edmund Foss was instrumental in securing $90,000 for a new Evanston post office. Located on the southwest corner of Sherman Avenue and Church Street, the top view looking north shows the dusty roads of Evanston at the time and Haven School, named for Dr. Otis Erastus Haven (1849–1888), on the right. The real-photo card below, postmarked 1930, shows a view of the post office looking south down Sherman Avenue. The streets show the streetcar tracks that were in use, an automobile shop, and city hall, which can be seen on the left. The post office moved to 1101 Davis Street in 1938. (VOG and PLH.)

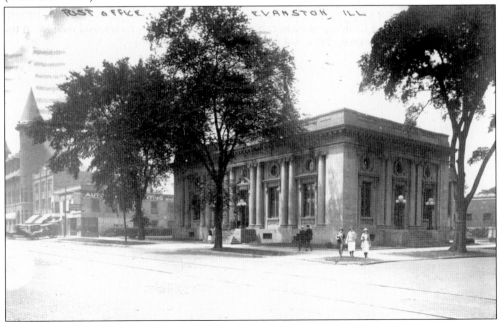

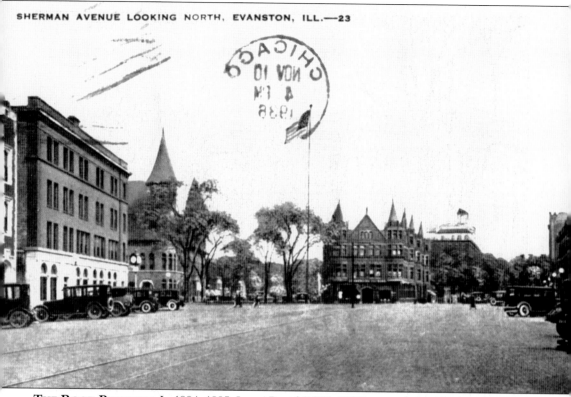

THE ROOD BUILDING. In 1894–1895, James Rood (1820–1909) commissioned John T. Wilson Jennings to design a four-story business block on the triangular site between Davis Street and Sherman and Orrington Avenues. The building had many gables and towers and included terra-cotta decorations. The building was destroyed by fire on February 16, 1946. Beginning on the far left, this card shows 1576 Sherman Avenue, City National Bank, Fountain Square, and city hall; the Rood Building at center; behind it the Orrington Hotel; and ending on the right, the Library Plaza Hotel. This card is postmarked 1936. (ECK.)

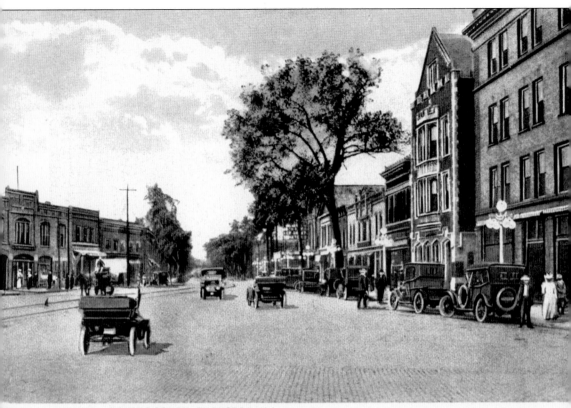

HERMAN AVENUE, LOOKING SOUTH, EVANSTON, ILL.

A VIEW OF 1576 SHERMAN AVENUE, C. 1900. Looking south, this card shows the redbrick building (right) built by Anton Blocks in 1886. For three years beginning in 1889, the Evanston Public Library was located there. Once the library relocated to its new quarters on the second floor of the new city hall building, the YMCA moved in. The YMCA purchased a new building on Orrington Avenue, and James Russell Smart (1871–1929), Evanston's mayor from 1913 to 1915, purchased the building in 1911; in 1912, Holabird and Roche remodeled it. Today the building remains an Evanston landmark next to 105 condominium units that were developed as the Optima Towers in 2002. (PRV.)

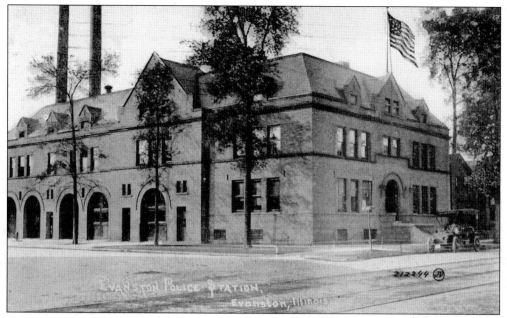

EVANSTON POLICE AND FIRE. Farther south on Sherman Avenue, this card, postmarked 1911, shows the Evanston police and fire departments located on the northwest corner of Sherman Avenue and Grove Street. The police department entrance was located on Sherman Avenue and provided jail cells, offices, and a "tramp room" in the basement. The three-story building was designed by J. T. W. Jennings and completed in 1897. (SHK.)

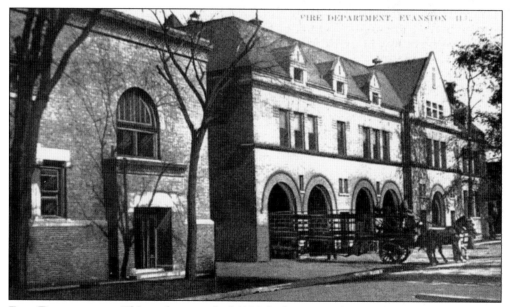

FIRE DEPARTMENT. This card postmarked 1913, looking east, shows the Grove Street entrance to the fire department. This side of the building housed engines, horses, and lofts for grain and hay. The dual station remained at that location until 1949, when a new building was constructed a few blocks away on the northwest corner of Lake Street and Elmwood Avenue, where police and fire services are still maintained today. (S, courtesy of the Evanston History Center.)

6626. New Theatre, Evanston, Ill.

VALENCIA THEATRE. The Evanston Theater once stood at 1560 Sherman Avenue, the present site of the Rotary International building. Built for the Evanston Amusement Company in 1910–1911, it was designed by John Edmund Oldaker Pridmore (1867–1940). H. Neilson and Company decorated the interior, which included furniture and fixtures from Marshall Field and Company. In 1917, the 950-seat theater that featured "polite vaudeville" suffered a fire and losses of $35,000. It reopened as the Evanston Strand Theater in 1918, and again in 1922 under the name New Evanston Theater. It was taken over by Balaban and Katz in 1932, and renamed the Valencia Theatre. The Valencia Theatre was razed for the American Hospital Supply building in 1975. This postcard is postmarked 1913. (SHK, courtesy of the Evanston History Center.)

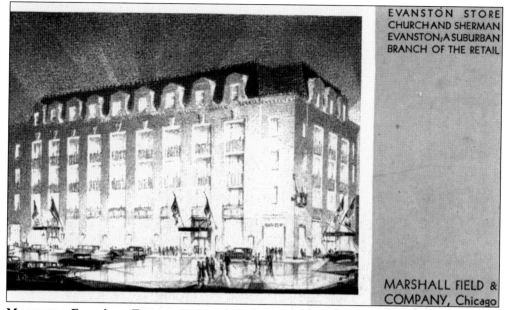

EVANSTON STORE
CHURCH AND SHERMAN
EVANSTON; A SUBURBAN
BRANCH OF THE RETAIL

MARSHALL FIELD &
COMPANY, Chicago

Marshall Field's in Evanston. Marshall Field and Company first began selling infant and children's clothing in the former Thomas C. Hoag house at 500 Davis Street in 1928. Later Marshall Field and Company expanded the line to include women's clothing and occupied the Carlson Annex Building at 620 Church Street. Finally in 1929, Marshall Field and Company announced it would develop the former Haven School site on the northwest corner of Sherman Avenue and Church Street with a million-dollar store. Designed by Graham, Anderson, Probst and White, the new store opened with much fanfare on November 23, 1929. Marshall Field and Company was a major anchor for downtown Evanston until the store was closed in 1987. Redeveloped in 1988 by Centrum Properties, the building remains as a mixed-use retail and condominium building. On the back side, the signature Marshall Field and Company's clock flanks the words "Post Card."

POST CARD

PLACE
STAMP
HERE

THIS SPACE FOR MESSAGE

THIS SPACE FOR ADDRESS ONLY

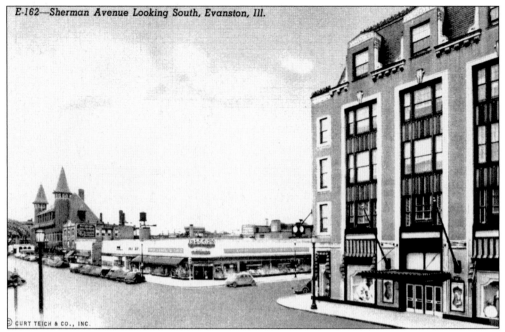

E-162—Sherman Avenue Looking South, Evanston, Ill.

© CURT TEICH & CO., INC.

KRESGE'S ON SHERMAN AVENUE, C. 1946. Across the street, the old post office was torn down in 1938 to make way for the S. S. Kresge store designed by Alfred Samuel Alschuler (1876–1940) in 1939. In this view looking southwest, Marshall Field and Company is shown on the right, the S. S. Kresge store at center, and city hall on the left. Three years later, the card below taken from nearly the same vantage point as the card above shows Sherman Avenue looking south. Beginning on the left are 708 Church Street; the Hahn Building; and in place of the Rood Building, the five-story Maurice L. Rothschild Building designed by Alfred Samuel Alschuler Jr. and Nathan Friedman. On the right, on the former city hall site, the four-story office building at 801–805 Davis Street that became known as the Three Sisters Building opened in 1948. (CT.)

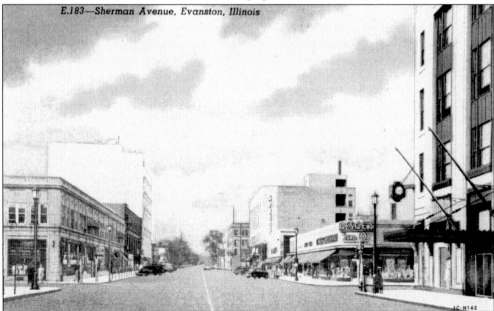

E.183—Sherman Avenue, Evanston, Illinois

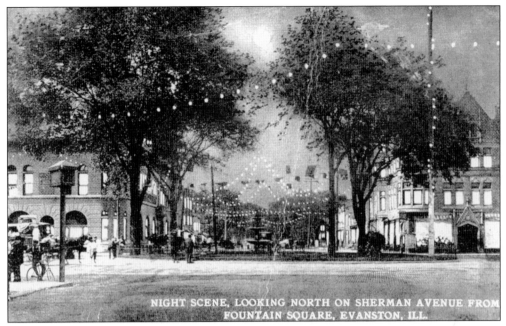

NIGHT SCENE, LOOKING NORTH ON SHERMAN AVENUE FROM
FOUNTAIN SQUARE, EVANSTON, ILL.

CENTENNIAL FOUNTAIN, 1914. On July 4, 1876, Evanston residents gathered in the heart of town to commemorate the nation's independence and its 100th birthday. A fountain nearly 15 feet high, made of cast iron and three tiers and with a crane that spouted water on top, was presented to the city council as a gift with a petition to provide a base. Signers of the petition included H. G. Powers, J. H. Kedzie, and O. H. Mann. The fountain was originally located in the middle of Sherman Avenue, just southwest of the present Bicentennial Fountain, where it remained until 1946. The postcard shown above captures Fountain Square glowing for celebration, with city hall on the left and the Rood Building on the right. The card below, postmarked 1908, shows the same view, looking north. (CT and SHK.)

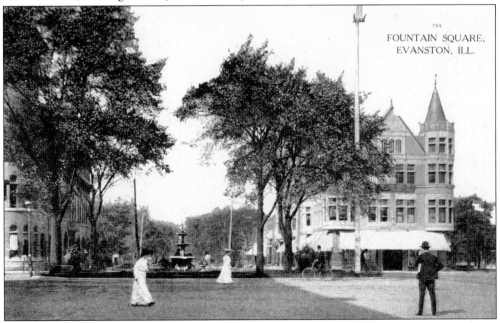

769
FOUNTAIN SQUARE,
EVANSTON, ILL.

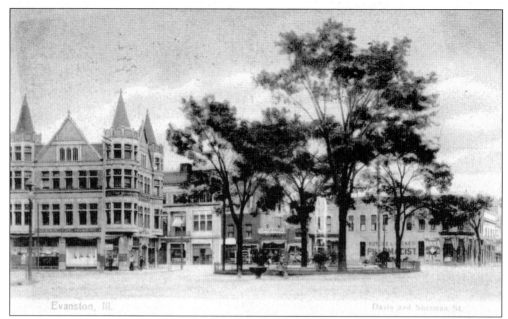

Evanston, Ill. Davis and Sherman St.

ORRINGTON AVENUE, EASTERN SIDE OF FOUNTAIN, 1905 AND 1911. The above postcard shows Orrington Avenue from Davis Street looking east. The brick building on the northeast corner of the intersection was the new location of Garwood's drugstore, formerly housed in the building to the north, next door. When the Rood Building (left) opened, photographer Charles E. Smith set up shop in the southeast corner of the building's first floor, and William S. Lord moved the Enterprise from the Haskin Block into the rest of the first floor of the building in 1895. The view below shows the State Bank of Evanston, designed by Phillips Rogers and Woodyatt and built in 1905–1907. In 1906, Lord's Famous Shop moved into the new building next to the State Bank of Evanston. Shown in both photographs is the cast-iron fountain surrounded by an oval-shaped oasis of water and grass. (CT and CRC.)

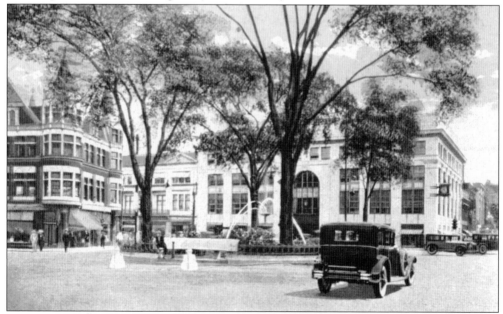

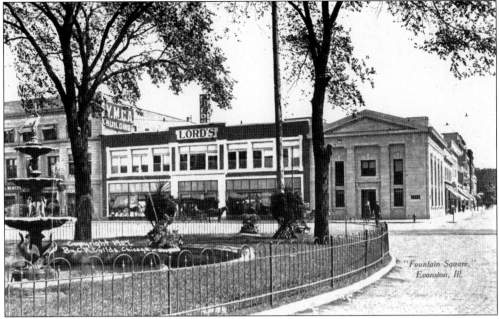

"Fountain Square," Evanston, Ill.

GROWTH AROUND THE FOUNTAIN. The next two postcards show the same northeast intersection of Davis Street and Orrington Avenue looking east. The above card shows the 1914 addition to the State Bank of Evanston, designed by architect Ernest Woodyatt, that doubled the size of the building and extended it east on Davis Street. In 1919, the bank was renamed the State Bank and Trust Company, and the bank prepared for further expansion that would come in 1929, shown in the card below. The Rood Building is on the left, and the fountain is in the foreground. The undated card below shows the building at 1611–1621 Orrington Avenue, designed by Holabird and Roche for the YMCA in 1898. After the YMCA moved out of the building in 1929, Lord's Department Store moved into the building. (ECK and MRS.)

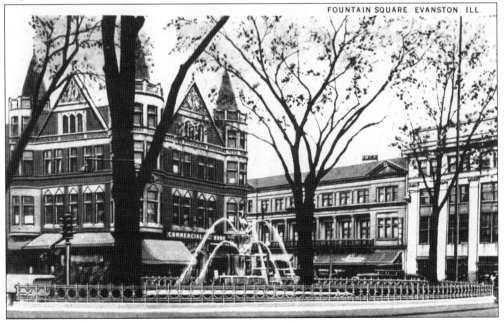

FOUNTAIN SQUARE, EVANSTON, ILL.

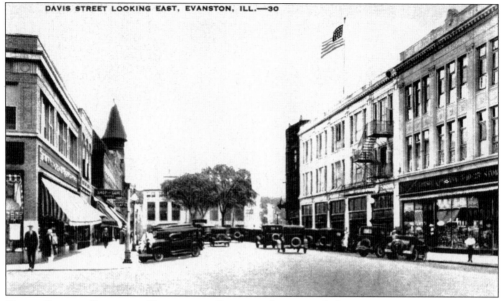

DAVIS STREET LOOKING EAST FROM BENSON AVENUE. A fixture in Evanston since 1916, the F. W. Woolworth Company at 825 Davis Street can be seen on the left, and Weiboldt's Department store at 810–816 Davis Street is on the right. Weiboldt's moved in 1952 to Church Street, and the old building originally built in 1889 was later demolished. The F. W. Woolworth Company building remained until it was replaced with a 1,585-space parking garage as part of the Sherman Plaza redevelopment plan.

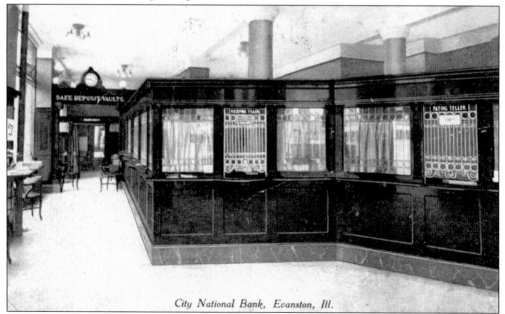

City National Bank, Evanston, Ill.

CITY NATIONAL BANK. This card, postmarked 1907, shows the inside of the Century Building, located on the southwest corner of Davis Street and Sherman Avenue. Built for Charles Comstock in 1899–1900, City National Bank opened on June 21, 1900, with Charles Dawes Gates as the comptroller of currency. The bank closed for business exactly 33 years later. The building, however, survived until 1954, when it was demolished for the First National Bank's new building. (SC.)

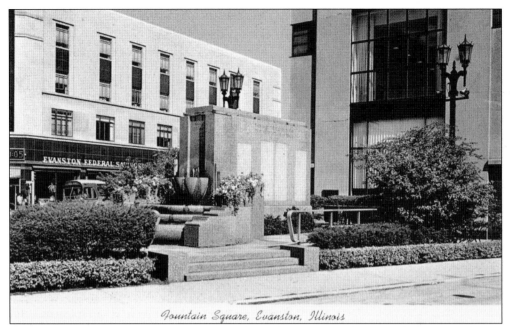

Fountain Square, Evanston, Illinois

WAR MEMORIAL AFTER REMODELING. In 1944, the city council approved recommendations from the war memorial committee to relocate Centennial Fountain to a more suitable environment and restructure Fountain Square to accommodate the war memorial south of the Rood Building. Designed in 1947 by Hubert Burnham, ground was broken for the three-basin recirculating fountain in April 1949, and the dedication ceremony was held on Armistice Day, November 11, 1949.

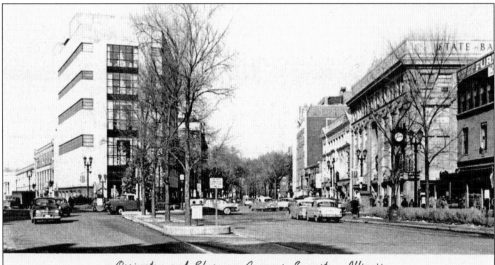

Orrington and Sherman Avenues, Evanston, Illinois

ORRINGTON AND SHERMAN AVENUES AT DAVIS STREET, LOOKING NORTH. Centennial Fountain was carefully removed in 1946 but languished in the city yards for four years. Vera McGowan, a restaurateur, contributed $5,000 to a restoration campaign to help make the fountain's rededication in Merrick Park possible. This card shows the intersection after the relocation of Fountain Square and the construction of the five-story Maurice L. Rothschild Building, with the Library Plaza Hotel, Lord's Department Store, and the State National Bank Building on the right. (CT.)

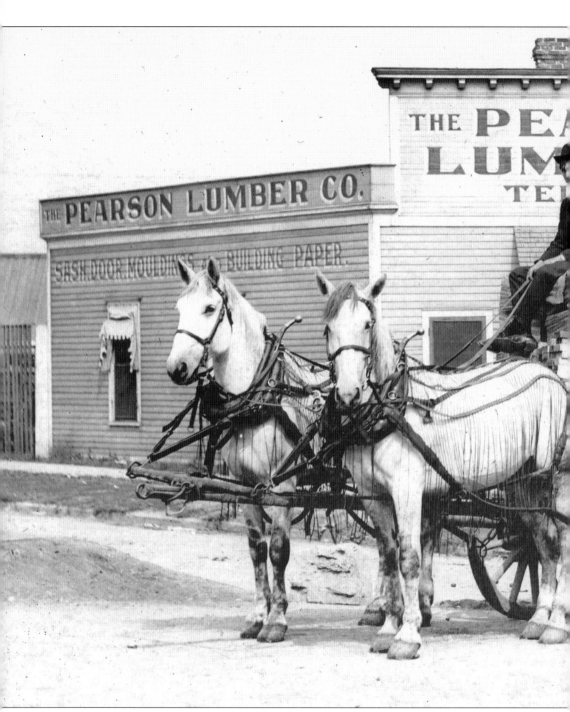

PEARSON LUMBER, c. 1880. In 1854, John Alonzo Pearsons (1818–1902), at the encouragement of his friend Dr. Hinman, came to Evanston and built a house on university land near what would become Raymond Park. The Davis Street Pier had not yet been built, and the lumber for his house came straight off the shore. Pearsons went into the general teaming business to provide building materials and other merchandise to the influx of people brought to Evanston by the railroad. For 18 years, he operated Pearsons' Evanston Express, employing many teams and wagons between

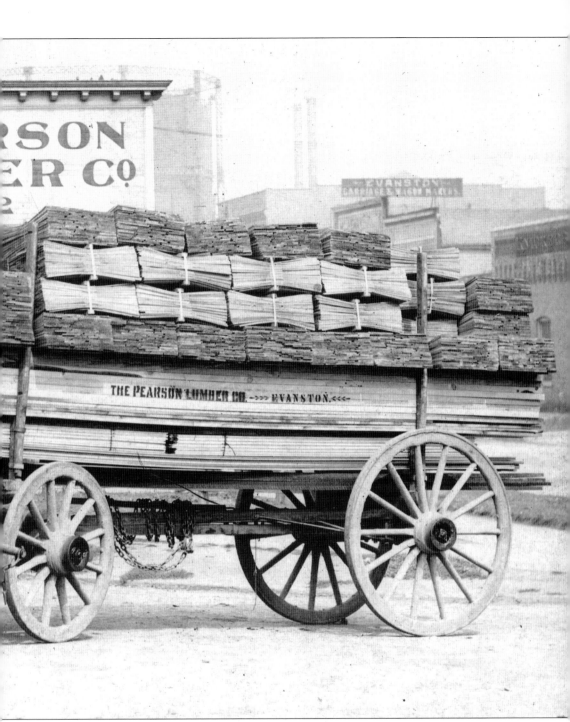

Evanston and Chicago. In 1872, he sold his express line, became interested in lumbering, and spent the next 12 years operating a lumberyard near the present site of Borders Books on Maple Avenue north of Church Street, with a storefront office on Sherman Avenue. His eldest son, Capt. Henry Alonzo Pearsons, served in the Civil War in the Eighth Illinois Cavalry.

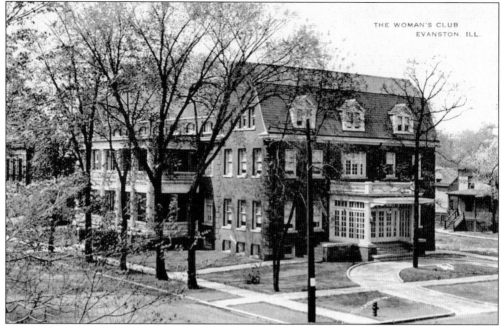

WOMAN'S CLUB. The Woman's Club had its beginning in 1889, with a small group of women who began holding meetings at the home of author, lecturer, and suffragette Elizabeth Boynton Harbert (1845–1925). Its mission was "to secure better homes, wiser motherhood, truer citizenship, better laws and a nobler womanhood by promoting physical, social, mental, moral and spiritual development of its members." The women met in various places, including the Evanston Country Club, the YMCA, and the Evanston Boat Club. In 1910, the club secured the northwest corner of Chicago Avenue and Church Street for a clubhouse and began a fund-raising campaign. The building was designed by Ernst A. Mayo and held its opening reception on March 11, 1913. The Woman's Club was instrumental in the development of the Evanston Emergency Hospital, which later became Evanston Hospital. (CT.)

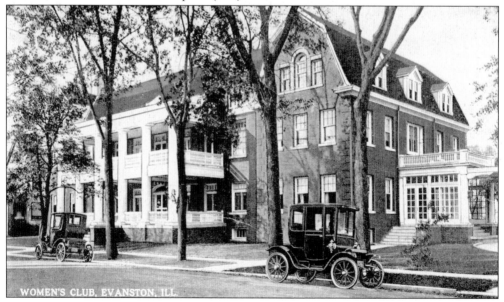

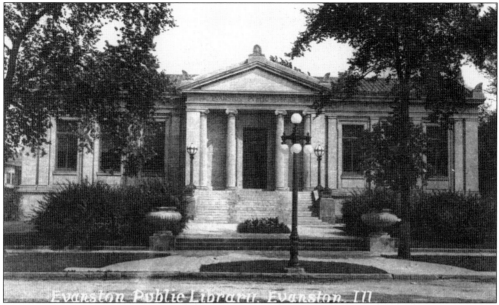

EVANSTON PUBLIC LIBRARY. Since 1893, the free public library had been located on the second floor of city hall. The city council and the library board agreed to locate a new library at the northeast corner of Orrington Avenue and Church Street in 1904 and awarded Charles A. Phillips and James Gamble Rogers the design contract. Andrew Carnegie donated $50,000 of the $135,465 cost of the building. Constructed facing Orrington Avenue and Commercial Park, the cornerstone was laid on January 1, 1908. The classic revival building was built of Bedford limestone, and the interior was finished in mahogany. There were reading, reference, and children's rooms on the first floor. The basement housed a small stage, a children's hall, and a room for the Evanston Historical Society. The building was demolished in 1960 for a new library. The above card, looking east, is showing the library on Orrington Avenue from Commercial Park. The view below is from Church Street. (VOH and S.)

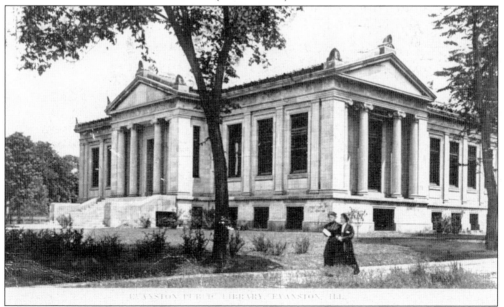

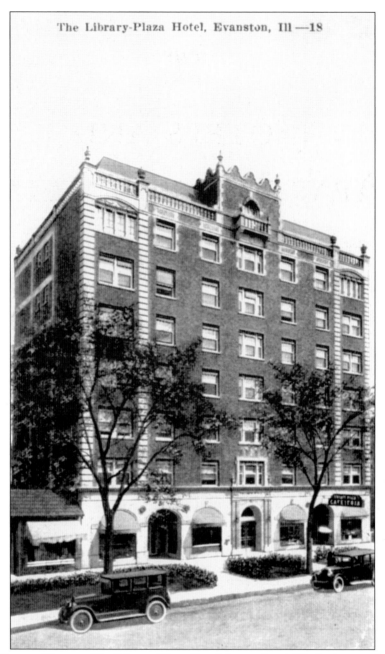

The Library-Plaza Hotel, Evanston, Ill—18

LIBRARY PLAZA HOTEL. The Library Plaza Hotel, located at 1637 Orrington Avenue, was designed for Victor C. Carlson (1888–1977) by George D. Connor and was known as Evanston's first skyscraper. The hotel was seven stories tall, with 71 three-room apartments. It opened in 1922 as the first in a group of projects that Carlson planned for "Library Square" in downtown Evanston. Next, across the street from the library at 1710 Orrington Avenue, Carlson planned to build a 300-room hotel. In addition, between 1925 and 1926, Stanley M. Peterson designed the Carlson Building at 636 Church Street and the Carlson Annex at 618–624 Church Street, built in 1928 for the Carlson Organization. During the Depression, the Carlson Organization was forced into bankruptcy and dissolved. This card is postmarked 1926. (ECK.)

Four

Hotels and Apartment Hotels

The first apartment buildings in Evanston were built close to the business district in the late 1880s. Evanston was concerned about the numerous apartment buildings appearing in Rogers Park and did not want to duplicate that in Evanston. In 1913, the area south of Calvary Cemetery called the Germania Subdivision petitioned the city to de-annex from Evanston because residents did not feel that they were receiving their fair share of city services. In 1916, after 175 apartment buildings had been built, the city established restricted residential districts due to fear that all of Evanston would become large apartment buildings and adopted a building code that required a 17-foot setback from the street. In spite of the new restrictions, 76 more large apartment buildings were constructed.

In 1919, the state legislature began allowing cities and towns to regulate land use. Evanston became the first city in the state to utilize the new tool by passing the Municipal Zoning Ordinance of 1921. The ordinance set aside zones or areas specifically for apartment buildings, residential, commercial, and industrial use. By 1921, the *Evanston News-Index* was reporting another building boom and rapid growth of the central business district.

The Georgian Hotel (1926) was one of a number in a series of apartment hotels built between 1919 and 1929 in the central business district. Other buildings included in that group are the North Shore Hotel (1919), the Library Plaza Hotel (1922), Orrington Hotel (1927), and the Homestead Hotel (1928). Of those, many consider the Georgian Hotel to have been the most luxurious of its class. On the south end of town along Main Street, more apartment hotels were being built. The Evanston Hotel (1916), the Evanshire Hotel (1923), and the Ridgeview Hotel (1924) all were competing for the semitransient customer. The stock market crash of 1929 and the Depression served to slow expansion until the economic crisis passed. On March 15, 1984, more than 50 apartment buildings were admitted to the National Register of Historic Places in the Suburban Apartment Buildings Thematic District.

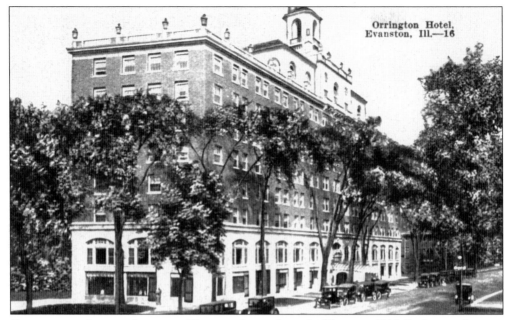

ORRINGTON AVENUE LOOKING NORTH. Across from the library at 1710 Orrington Avenue, ground was broken in 1923 for another seven-story hotel, the Orrington Hotel. Completed in 1927, the second building in Victor Carlson's short-lived empire was designed by Frank William Cauley (1898–1984). The elaborate building had a rooftop ornamental tower to camouflage the vents and mechanical equipment and also provided open space for a landscaped lounge with pergolas. (ECK.)

ORRINGTON AVENUE LOOKING SOUTH, C. 1950. This view shows the Carlson Building on the southeast corner of Orrington Avenue and Church Street looking south, followed by the Library Plaza Hotel (left). The Rothschild Building is on the right next to the Hahn building, an Evanston landmark, built by John Knight in 1927 and the 708 Church Street building constructed in 1923. Today the Plan Commission is considering a proposal by Focus Development to build a 49-story residential tower at 708 Church Street that does not include reconstruction of the city-owned Fountain Square property.

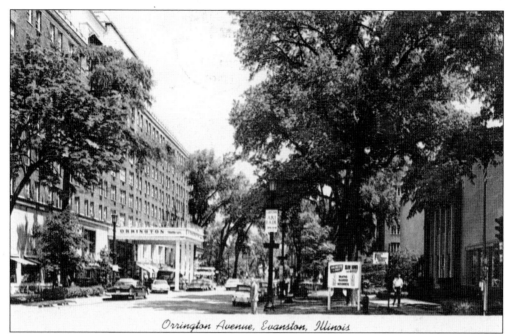

ORRINGTON HOTEL, LOOKING NORTH. In addition to 300 hotel rooms, the Orrington Hotel offered 72 apartments and retail shops on the ground floor. This view shows Orrington Avenue looking north and the Evanston Public Library on the right. During 1965–1968, Orrington Avenue was closed to traffic to allow the construction of the Rebecca Crown Administration Building and clock tower. (CT and JOS.)

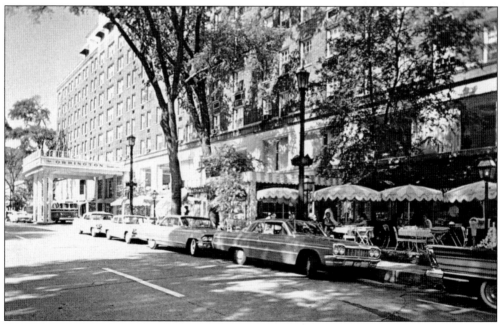

ORRINGTON HOTEL, LOOKING SOUTH. An addition was built on the north side of the Orrington Hotel in 1924. This card shows the outdoor café boasting "a unique outdoor dining experience and offering a vast array of selection, served with elegance." (JWI.)

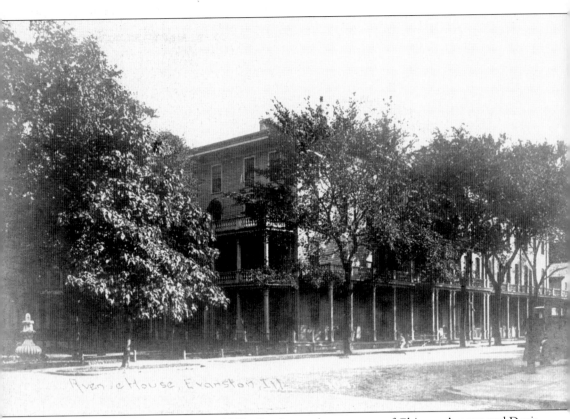

Avenue House, Evanston, Ill.

EVANSTON'S GREAT HOTEL, C. 1899. On the northeast corner of Chicago Avenue and Davis Street, where the North Shore Retirement Hotel is located, once stood the Avenue House. In 1854, James B. Colvin had a one-and-a-half-story house built while he was postmaster. Albert Danks purchased the property in 1857 and renamed it the Danks Hotel. Shortly thereafter, Danks sold to George W. Reynolds, who of course changed the name to Reynolds House. It was the Reynolds House that Frances and Mary Willard visited when they came to Evanston in 1858. In 1863, when Seth A. Mattison became the owner, the name was changed to Mattison House. During 1872, a portion of the building was moved away from the street and a 100-foot addition with 65 rooms was built. In 1874, Dr. Charles H. Quinlan (1821–1897) acquired and opened the hotel in 1875 under the name the Avenue House, a name it maintained for more than 40 years. The building was demolished in 1917 to make way for the North Shore Hotel.

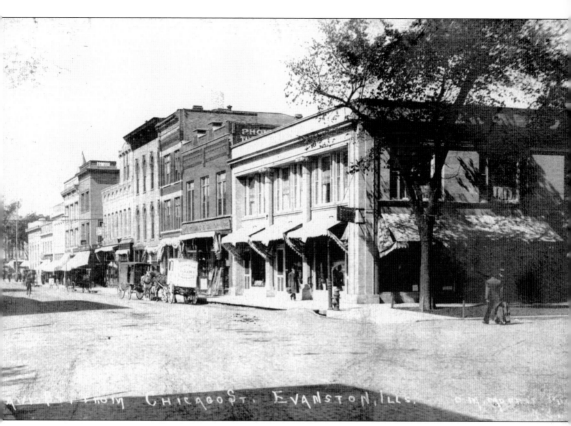

DAVIS STREET FROM CHICAGO AVENUE. This view of the 600 block of Davis Street, while not showing any hotels, shows the business district from the southeast corner of Chicago Avenue looking west, during the same time period as the previous postcard, when the Avenue House was across the street. Together the two cards place the viewer at the intersection of Chicago Avenue and Davis Street. Today the building seen on the northwest corner houses Accents Plus, a women's boutique. The horse and wagon in the photograph is showing Bowman's Dairy on the back of the wagon. The three-story building west of the intersection was built by Dr. Washington S. Scott in 1870 and housed the Masonic Hall from 1870 to 1889. The first floor contained a hardware store, a boot and shoe store, and the post office. This card is postmarked 1910. (CRC.)

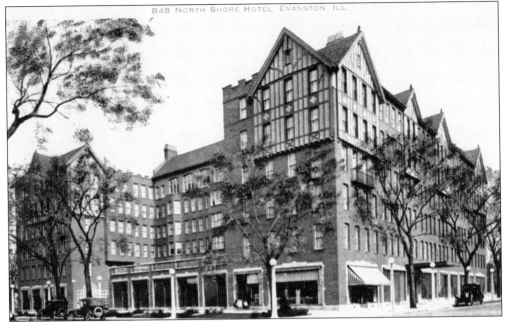

THE NORTH SHORE HOTEL, 1938. A proposal to construct a six-story luxury hotel at the northeast corner of Chicago Avenue and Davis Street was made by Frank M. Anderson, Louis M. Nelson, and John Lundquist. The North Shore Hotel, 1611 Chicago Avenue, was to include 19 retail stores at its base, with entrances from both Chicago Avenue and Davis Street. Designed by Robert Seely DeGolyer (1876–1952), the hotel would have 192 rooms and 48 kitchenette apartments, a solarium on the sixth floor, a dining room, a coffee shop, a ballroom, and banquet halls. The building was constructed of brown brick with stucco and half-timbering on the upper two floors. The hotel opened on March 29, 1919, and remains today as a retirement hotel. (VOH and CT.)

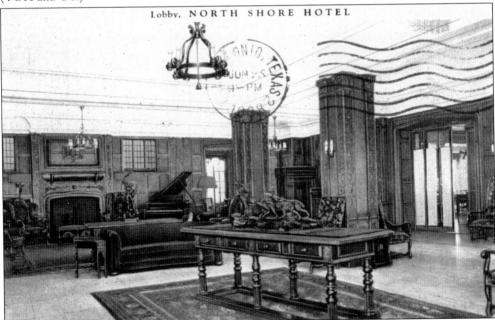

Lobby, NORTH SHORE HOTEL

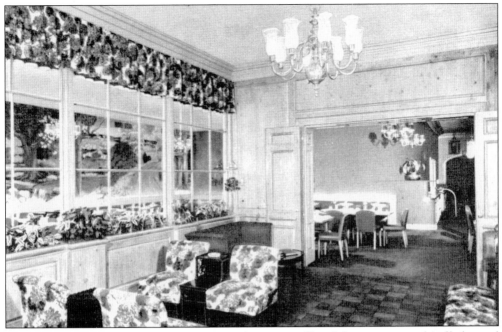

TALLY HO RESTAURANT. The next two cards are not of hotels but are geographically located and thus included at this point. Roy W. Cooley sold his chain of restaurants, founded in 1925, to George D. Hanby in 1951. The sale included the Tally Ho Restaurant shown in the view above. The restaurant continued to operate at 1513 Chicago Avenue north of Davis Street and was later purchased by Gerry Bringman. In 1962, the dining room and patio underwent renovations and reopened with a 60-foot glass wall installed in the Garden Room. The view opened to a landscaped patio, which was illuminated with light at night. The postcard below shows the landscaped garden surrounding the patio, and both views are from 1947 prior to renovations. (CT.)

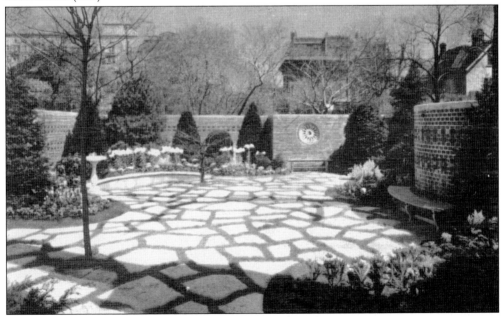

49

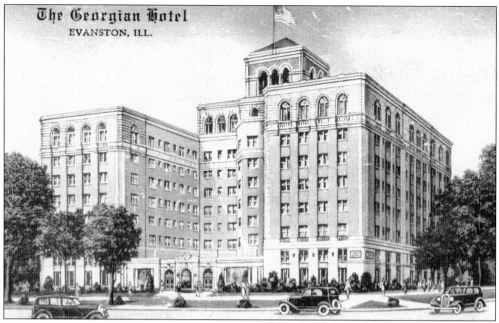

THE GEORGIAN HOTEL. With 343 rooms, the Georgian Hotel was built at a time when Evanston was experiencing a building boom in 1926. The seven-story building on the southeast corner of Hinman Avenue and Davis Street, built for Henry Paschen and Albert Pick, was designed by Albert S. Hecht, an Evanston resident and architect who specialized in luxury apartment buildings, hotels, and residences and was especially expert in the use of terra-cotta. (CT.)

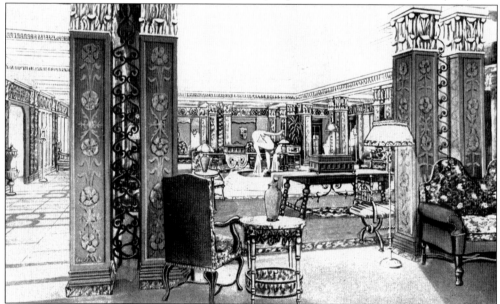

GEORGIAN HOTEL LOBBY. Hecht was inspired to build the hotel after a vacation to Rome and spared no expense, importing rare travertine marble from Italy for walls and floors, as well as commissioned hand-painted murals and friezes. This lobby view, looking east, shows how Hecht used terra-cotta columns throughout the building. In addition, terra-cotta was used as a cornice over bay windows and to define wings and other areas, giving them a special flourish. (CT.)

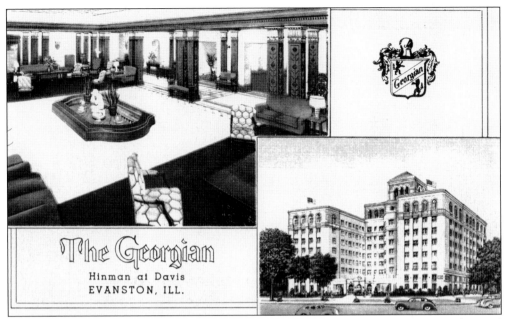

HINMAN AT DAVIS. The building, constructed in 1926 with its distinctive terra-cotta styling and structure, stood out among the other hotels constructed around the same period. Despite protracted debate and qualifying for listing in the National Register of Historic Places on September 17, 2004, the Georgian Hotel will be demolished. This card shows the lobby looking north and boasts of "one to six room apartment homes, tastefully furnished and decorated." (CT.)

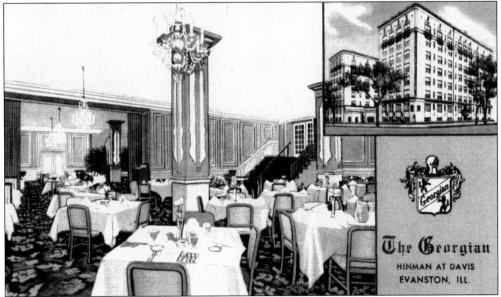

THE MAIN DINING ROOM. Mather LifeWays, the not-for-profit group that operates Mather Place at the Georgian Hotel, is scheduled to replace the building by 2011 under the $130 million development plan approved by the city council on March 13, 2006. The building will include 245 independent living residences, in addition to assisted-living and long-term care residences, with underground parking for 249 vehicles. This last view shows off one of four luxurious dining rooms in the Georgian Hotel. (CT.)

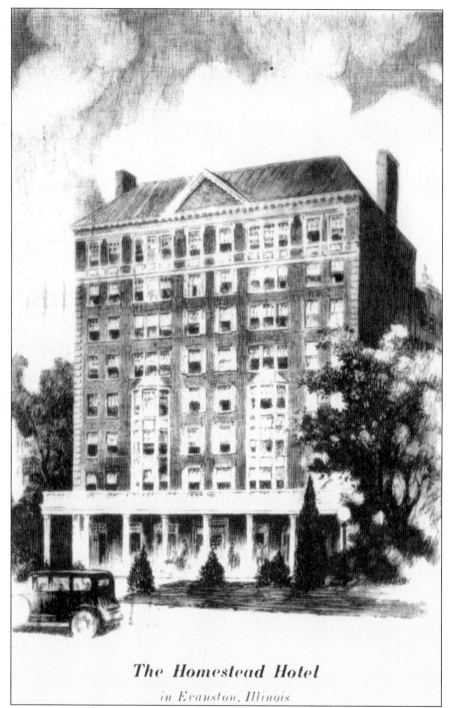

The Homestead Hotel

in Evanston, Illinois

HOMESTEAD HOTEL. With 90 rooms and eight stories, the Homestead Hotel opened at 1625 Hinman Avenue on February 10, 1928. Located just north of Davis Street on the east side of Hinman Avenue, the building was designed by architect and contractor Philip A. Danielson and his wife, Ruby Larson, as interior decorator. The building was listed on the National Register of Historic Places in February 2006. This card is postmarked 1939.

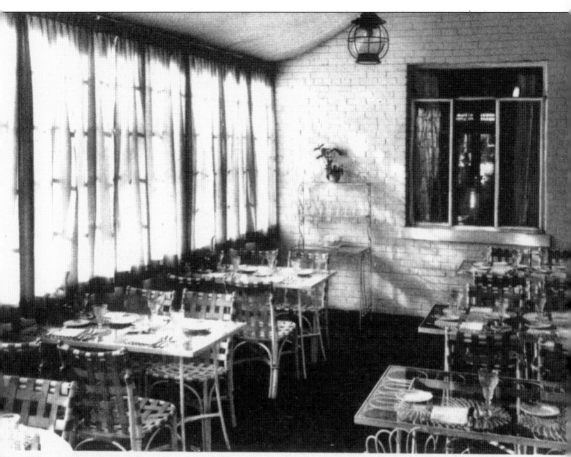

he *Homestead Hotel* *Evanston, Illinois*

HOMESTEAD RESTAURANT. Restaurants located in the Homestead Hotel have a legacy of serving elegant cuisine. Until 1977, the in-house restaurant was known as the namesake Homestead Restaurant. From 1977 to 1993, Café Provencal was located there under the management of Leslie Reis. In 1993, Trio took over operations in the kitchen and became nationally known as one of only 13 five-star restaurants in the entire nation. Today Quince is poised to continue the tradition of fine Homestead Hotel restaurants.

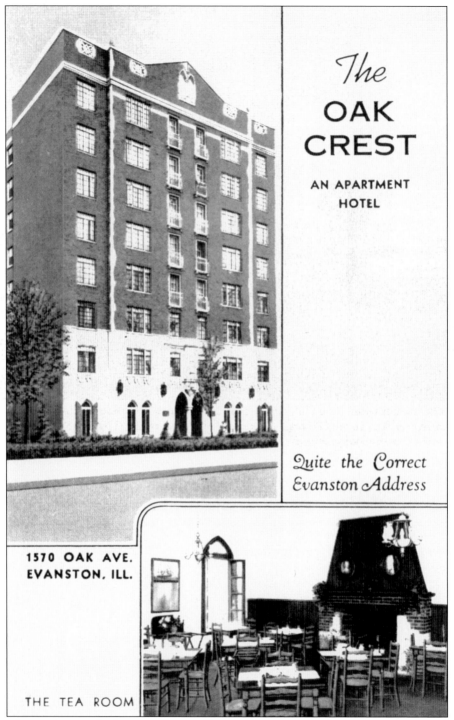

OAK CREST HOTEL. Before Engelhart Hall opened in 1970, Northwestern University offered housing for some of its married graduate students in the Oak Crest Hotel at 1570 Oak Avenue. The university purchased the 105-unit building, a mix of one-to-three-room kitchenettes, in 1960 and named it for George B. Dryden, a member of the board of trustees. (CT.)

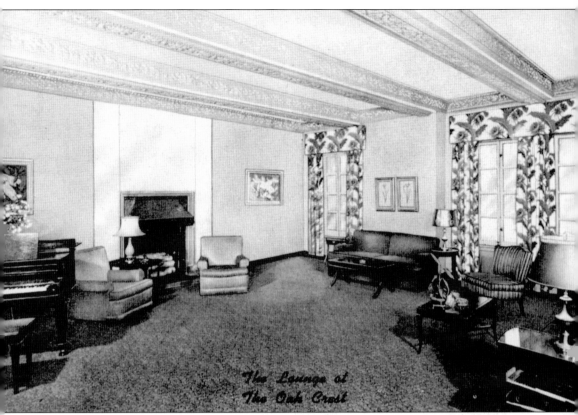

The Lounge at
The Oak Crest

OAK CREST LOUNGE. The Oak Crest Hotel offered a "quiet, congenial atmosphere, and unobtrusive service" in the Old English Room, a restaurant operated by Jean Peterson in 1954. This card shows the lounge area of the hotel.

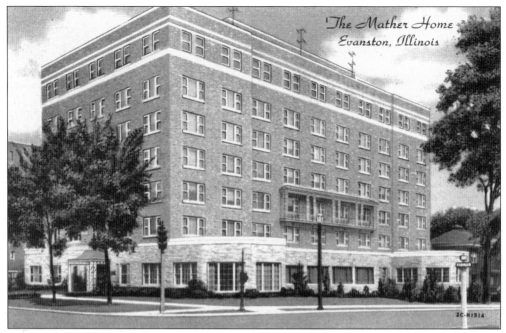

THE MATHER HOME. The Mather Aged Ladies' Home was built in 1950–1952. Alonzo C. Mather died in 1941, and his will provided that a "home be established to encourage the continued participation of its residents in the community." Designed by Childs and Smith, the building at 1615 Hinman Avenue was seven stories high, with an eighth story added later. The building was demolished in 2007 as part of the Mather LifeWays project mentioned on page 51. (CT.)

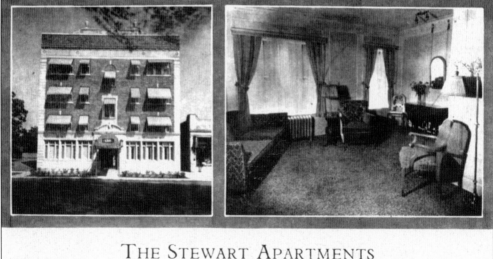

THE STEWART APARTMENTS
1311 CHICAGO AVENUE
EVANSTON. ILLINOIS :-: PH. GREENLEAF 4723

THE STEWART APARTMENTS. Today the condominiums known as the Stewart at 1311 Chicago Avenue occupy this building and outwardly it appears much the same, sans the awnings. This image advertising the Stewart Apartments appears on a postcard with an undivided back, dating the card from around 1907.

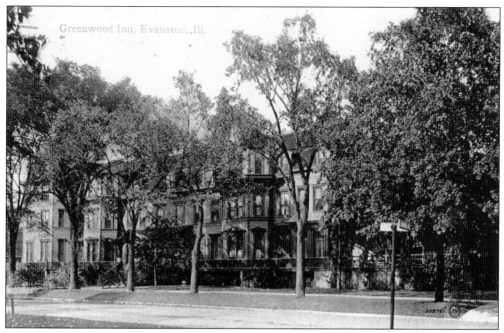

THE GREENWOOD INN, HINMAN AVENUE VIEW. Orvis French (1822–1897), originally from Vermont, moved to Evanston from Milwaukee in 1867. He operated a wholesale clothing store with his brothers John and Charles on Randolph Street in Chicago, called French Brothers and Company. His business was lost to the Chicago fire in 1871, and for many days he saw vehicles of every type carrying household goods north looking for a place to stay. Seeing an opportunity, he turned his home into a boardinghouse. This card is postmarked 1911. (V.)

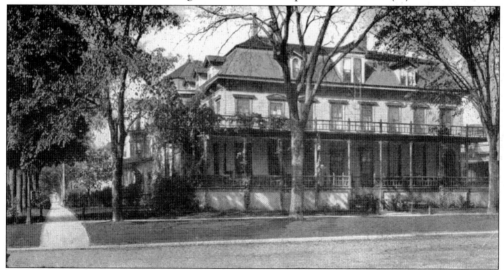

GREENWOOD STREET VIEW. Located at 1869 Hinman Avenue on the northeast corner of Greenwood Street and Hinman Avenue, French named the three-story double house the French House. Over the years, many additions were made, for a total of 125 rooms. French sold the property to Benjamin Bayless (1844–1920) in 1892, and after rehabilitation, the inn reopened in 1896 as the Greenwood Inn and remained open until 1952, when it was demolished. This card is postmarked 1909.

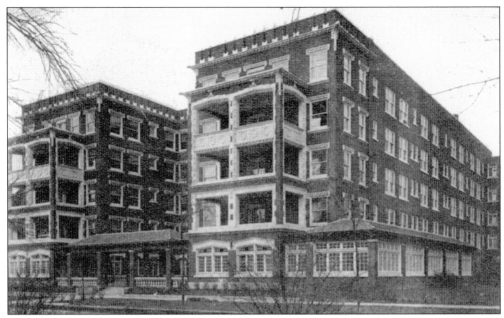

EVANSTON HOTEL. The Evanston Hotel was the first modern, fireproof apartment hotel outside of Chicago and was known as the "Model" on its opening night in 1917. This real photograph shows the Evanston Hotel at Main Street and Forest Avenue. The five-story building was built with 170 rooms in 1914–1916 by Lewis M. Nelson and Frank C. Lewin. Upon Lewin's death in 1922, the Evanston Hotel became the property of the Lewin estate. After falling on hard times during the Depression, the building was eventually purchased by Col. C. Wylie Allen, who also owned the Homestead Hotel. Colonel Allen remodeled the hotel's coffee shop in the decor of Abraham Lincoln's dining room on the president's private railroad car. The owner managed the hotel until his death in 1974. The building was demolished in 1975 and replaced with the condominiums that occupy the site today. The card below is postmarked 1933. (VOH and CT.)

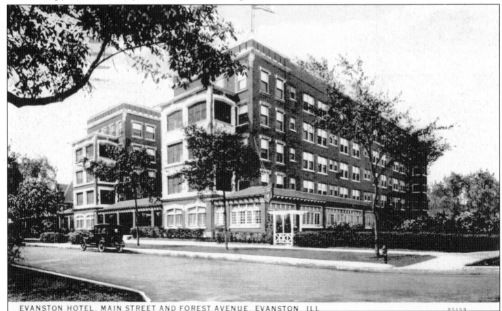

EVANSTON HOTEL, MAIN STREET AND FOREST AVENUE, EVANSTON, ILL.

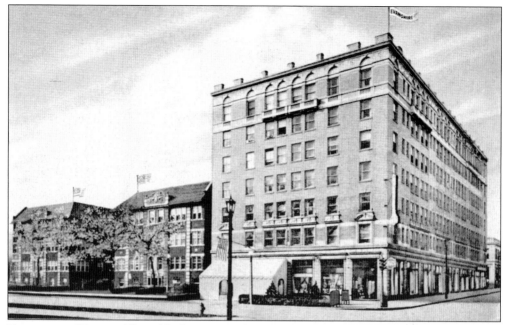

EVANSHIRE HOTEL. Three blocks away at the southwest corner of Main Street and Hinman Avenue the Evanshire Hotel was built. The hotel opened on September 1, 1923, as one project of the Main Street Building Corporation. The 128-room, seven-story building was built of pressed brick and light terra-cotta. Each room was built with two windows and equipped with a private shower and tub. The public rooms were finished in Italian marble, the register counter of Belgian marble, and the lobby floor was made of Alabama and Mapolion grey marble. The building was touted as one of the finest in residential hotel living in 1924 and remains today on Hinman Avenue. The card above is postmarked 1942. (AC and CT.)

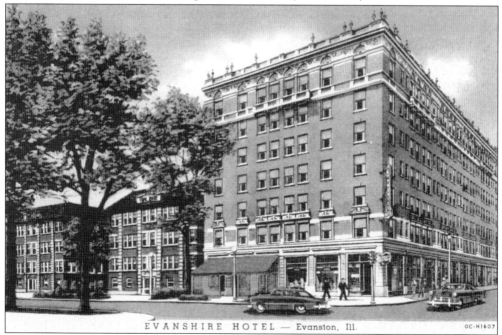

EVANSHIRE HOTEL — Evanston, Ill.

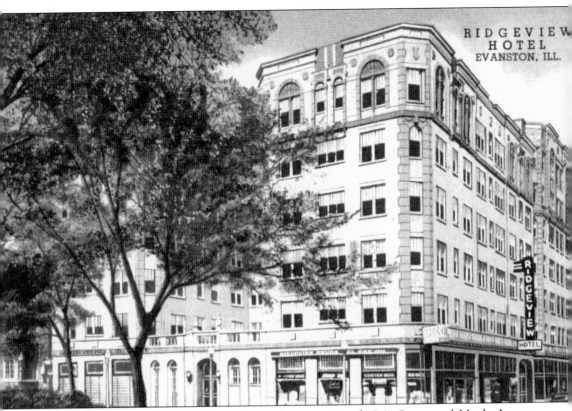

RIDGEVIEW HOTEL. In 1924, on the northeast corner of Main Street and Maple Avenue, another seven-story residential hotel was built for "those desiring convenience of hotel living." The Ridgeview Hotel offered modern kitchenette apartments and suites. The structure was built with an inside garage, banquet room, restaurant, and retail shops with entrances on both Maple Avenue and Main Street. In 1965, the building was purchased by David A. Zaranksy and remodeled extensively. Finally, in 1971, the building was sold again and converted into a 430-bed facility for state-assisted patients with disabilities. The building remains in use today as Albany Care. (CT.)

Five

SCHOOLS

In 1846, Ridgeville Township trustees were elected for school purposes. The township trustees made up the board of education, and in 1848, Osro Amandor Crain (1819–1898), E. Bennett, M. Dunlap, O. Munn, and George M. Huntoon were the members.

According to Olivia Hill, who married Osro Amandor Crain in 1843, the first school was built on the northwest corner of Ridge Avenue and what would become Greenleaf Street "either in 1841 or 1842." The one-room log cabin was built "on the ridge" with little more than half an acre of land to the west. This area contained an active burial ground that received continued use until 1872. The little school also served as a meetinghouse and a place for social activities and worship. Charles Crain's home was on the southwest corner of Greenleaf Street and Ridge Avenue, and his cooperage shop was across the street on the southeast corner. In 1874, thirty-three feet were taken from the school and cemetery grounds to "cut" Greenleaf Street to the proper width.

The first regular school tax was levied in 1856, at 50¢ on each $100 of taxable property. The first building of the school district to require bonded debt was the Benson Avenue School, which was nearly in the center of town, at Maple Avenue and Foster Street, and constructed about 1860. All of the school records of District 1 previous to 1872 were destroyed in the Chicago fire. Around 1888, the Benson School had to be moved, as it was located where the railroad was planned.

In 1855, William Patterson Jones (1831–1886) came to Evanston to establish a female school. The North Western Female College was constructed between Lake Street and Greenwood Street, and Sherman Avenue and Chicago Avenue. There the private institution, not affiliated with Northwestern University, built a four-story frame building for which the cornerstone was laid in June 1855. There were 83 students enrolled when the building opened in January 1856. The school merged with the Evanston College for Ladies in 1868. Evanston resident Frances E. Willard became its first president in 1871, and she began raising funds for a new building.

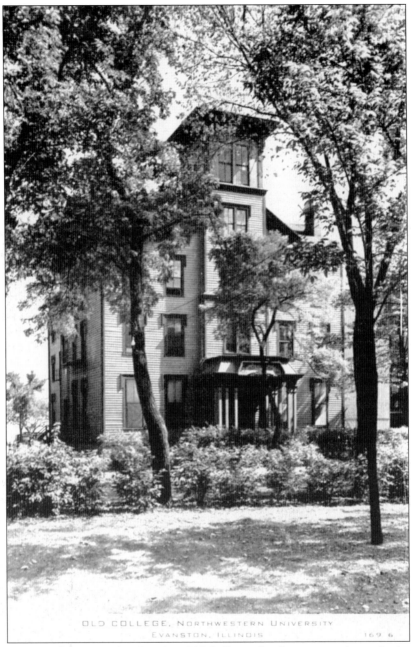

OLD COLLEGE, NORTHWESTERN UNIVERSITY
EVANSTON, ILLINOIS 169 6

OLD COLLEGE. This postcard is showing Old College after it was moved to a site just west of Fisk Hall. The first university building, which cost $6,000, was built on the northwest corner of Davis Street near Hinman Avenue. Ground was broken on June 15, 1855, and Bishop Mathew Simpson (1811–1884) presided over the ceremony. The building was 50 feet by 40 feet, three stories high, with an attic and a belfry. Inside, there were six classrooms, two halls for literary societies, a chapel, and a museum. The building officially opened in November 1855. In 1869, the building became the first feeder school for the university, known as the Preparatory School. It was moved to campus in 1871 and faced University Place (later Sheridan Road). After much debate, the building was demolished in 1973. (CRC.)

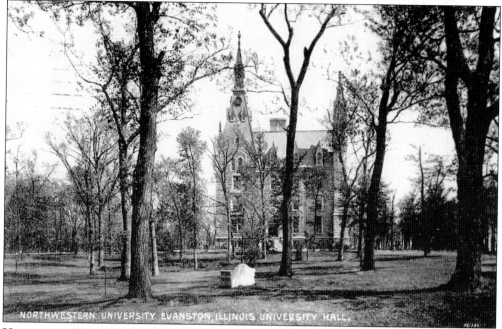

UNIVERSITY HALL. Designed by Chicago architect Gurdon P. Randall (1821–1884), construction on Northwestern University's "permanent building" began in 1867. The main tower was 120 feet tall, and the high Victorian Gothic structure was built of rock-faced Joliet limestone, stood three-and-a-half stories tall, and had an attic built for dormitories and a museum. The building contained classrooms, offices, a library, a chapel, and a laboratory. During the installation of Erastus Otis Haven (1820–1881) as president of the university, the new building was dedicated on September 9, 1869. These two postcards are postmarked 1910 and 1906, respectively. (HAP and RTS.)

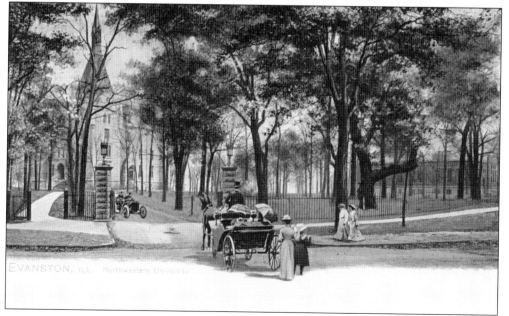

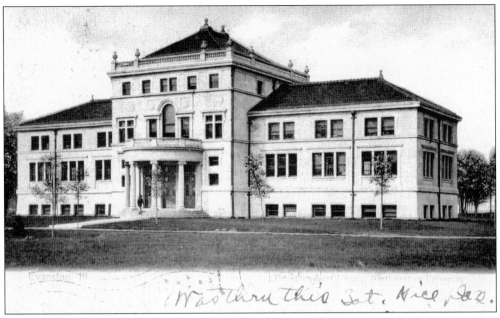

ORRINGTON LUNT LIBRARY. Orrington Lunt made a $50,000 contribution for the construction of a library suitable for the university in 1891. The new library was designed by William Augustus Otis (1855–1929) and would provide space for 100,000 volumes. The structure, in the style of the Italian Renaissance, was built of dressed Bedford limestone, and its roof was constructed of red Conosera tile. In this view, postmarked 1907, one cannot see the words "Orrington Lunt Library" that were inscribed above the portico. This card has an undivided back. (CT.)

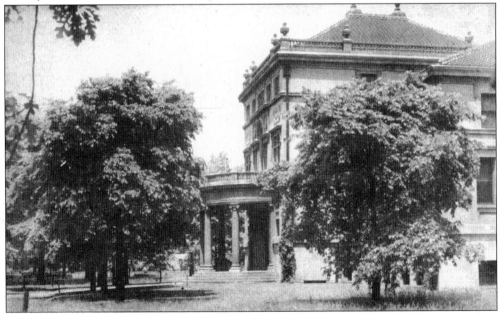

ORRINGTON LUNT LIBRARY, VIEW FROM SOUTHEAST. Lunt was born in Bowdoinham, Maine, on December 24, 1815. He was a member of the committee of safety and war finance in Chicago during the Civil War. In 1865, Lunt conveyed to Northwestern University 157 acres of land in what was then North Evanston, to be known as the Orrington Lunt endowment property.

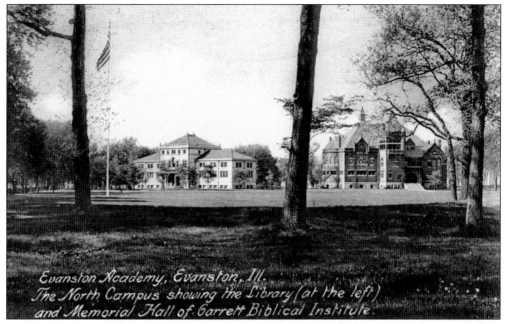

Evanston Academy, Evanston, Ill.
The North Campus showing the Library (at the left)
and Memorial Hall of Garrett Biblical Institute.

ORRINGTON LUNT LIBRARY AND MEMORIAL HALL. This real-photo card, postmarked 1907, shows the relationship between Orrington Lunt Library and Memorial Hall, which housed the library of over 5,000 volumes for the Garrett Biblical Institute. The Chicago architect who designed the water tower in Chicago, William Warren Boyington (1818–1898), designed Memorial Hall to commemorate the centennial of the Methodist Episcopal Church. Judge Grant Goodrich broke ground on May 13, 1885, for the new building. The building was made of pressed red brick with a base of gray sandstone and contained large lecture rooms, a library, and a chapel. The chapel windows were beautiful and "of exquisite coloring and design." Northwestern University purchased the building in 1923, and it was nicknamed the "Little Red Schoolhouse." The building was demolished in 1970. (VOH and RC.)

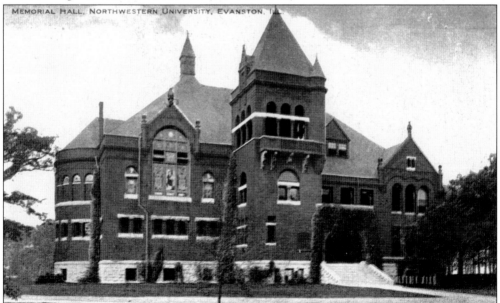

MEMORIAL HALL, NORTHWESTERN UNIVERSITY, EVANSTON, ILL.

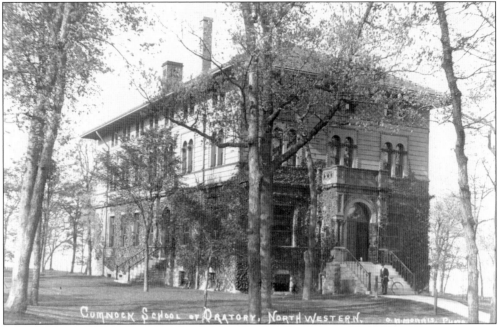

CUMNOCK SCHOOL OF ORATORY. Prof. Robert Cumnock pledged a contribution to Northwestern University to build a new school of oratory. However, the panic of 1893 caused him to seek funding from Gustavus F. Swift. The building was instead named after Swift's daughter, Annie May Swift, a Northwestern University student who died in 1889. Designed by Charles R. Ayars, the building's base is made of rock-faced Lemont limestone, its upper stories are Roman brick and terra-cotta, and its roof is made of red tile. Until the creation of the filled-lake campus in the 1960s, Annie May Swift Hall stood on Lake Michigan's shore, offering a view of the lake, as both the 1910 postmarked real photographs show. In 2002, the School of Speech was renamed the School of Communication. (CRC.)

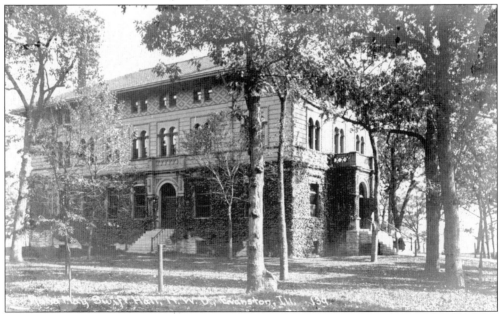

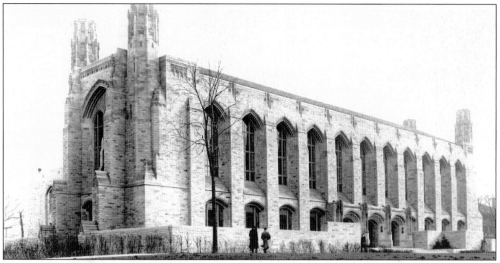

DEERING LIBRARY. The Charles Deering Memorial Library, which now houses the university's art and map collections, music library, and archives, was built with contributions from the Charles Deering estate, and a $1 million grant from Marion Whipple Deering in 1928. The library opened on December 29, 1932. Designed by New York architect James Gamble Rogers, the building was modeled after King's College Chapel, Cambridge, England (built from 1446 to 1515), and the interior was crafted with elaborate wood and stone carvings. This card is postmarked 1935.

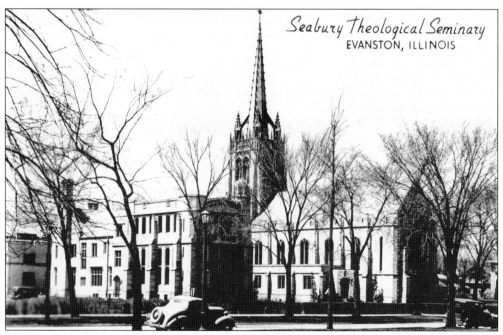

SEABURY THEOLOGICAL SEMINARY. Founded in Chicago in 1883, Western Theological Seminary announced plans to build at the southwest corner of Sheridan Road and Haven Street in Evanston. Neighbors protested the institutional use in the residential neighborhood, and the city amended its 1921 zoning ordinance to exclude dormitories. The case ended in court three years later with the Illinois Supreme Court ruling in favor of the seminary. This card shows the building after the merge between Seabury Divinity School and Western Theological Seminary in 1933. (GP.)

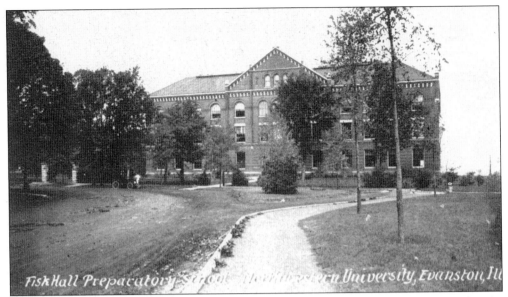

Fisk Hall Preparatory Schoolrn University, Evanston, Ill

FISK HALL PREPARATORY SCHOOL. This card shows Fisk Hall with Lake Michigan in the background. The preparatory school, an important source for university students, was renamed the Academy in 1892. Principal Herbert Franklin Fisk (1840–1916) set out to raise funds for a new building, and in 1896, with a contribution from William Deering, the plans were carried out. The building was designed by D. H. Burnham and Company. The building housed classrooms, a library, a chapel, laboratories, classrooms, and offices. (VOH.)

Evanston Academy, Evanston, Ill. Lake Michigan from rear of Fisk Hall

REAR FISK HALL. Fisk Hall, named in honor of Fisk, opened on January 27, 1899. Fisk resigned after 31 years as head of the Academy in 1904, and 13 years later, the school closed. After Fayerweather Hall was demolished in 1954, the Joseph Medill School of Journalism moved into Fisk Hall. In this view before the lake was filled, one can see how close the lake once was to the building. This card is postmarked 1910. (RC.)

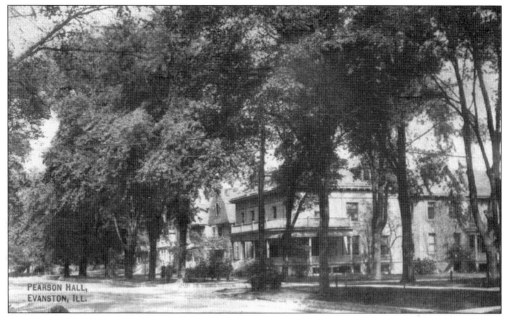

PEARSON HALL,
EVANSTON, ILL.

PEARSONS HALL. Pearsons Hall was originally a house on the northeast corner of Clark Street (the postcard below) and Orrington Avenue (above). It was purchased in 1872 by the Woman's Educational Aid Association (WEAA) as a boardinghouse for ladies. The ladies were under the immediate attention of the dean of the Woman's College, Frances E. Willard. Board was $2.75 per week, and the ladies were required to keep house modeled after the cottage system at Mount Holyoke. Hannah Bayley Pearsons served as president, and Deborah S. Cummings (1816–1900) was vice president. College Cottage at 1801–1807 Orrington Avenue underwent several renovations and expansions. The house had a parlor, a library, 14 sleeping rooms, 2 halls, and bathrooms. Verandas were added to the east and south sides of the first two floors in 1890. College Cottage was renamed Pearsons Hall in 1901 to honor 30 years of dedication to WEAA by Mrs. Pearsons. The card below is postmarked 1911. (V and ECK.)

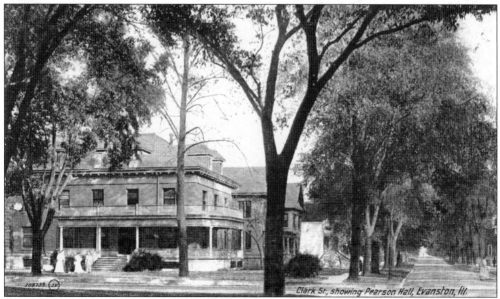

Clark St., showing Pearson Hall, Evanston, Ill.

69

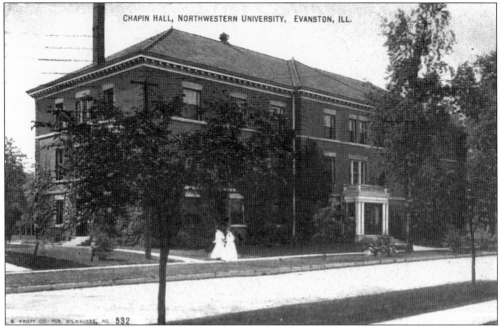

CHAPIN HALL. The WEAA was founded in 1871, with a goal to provide higher education for deserving students at the Evanston College for Ladies. The association assumed Chapin Hall's management in 1901 and operated it for "women of slender means" until 1968. The three-story dormitory at 726 University Place descended from what was formerly known as College Cottage. Chapin Hall, seen on this card postmarked 1911, became a coed dormitory in 1980. (ECK.)

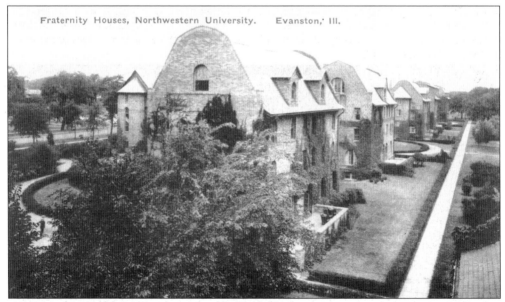

MEN'S QUADRANGLE. This card shows Sheridan Road (left) and the six buildings of the Men's Quadrangle, which are still located on the east side of Sheridan Road between Colfax and Noyes Streets, looking northwest. The buildings were designed by Palmer, Hornbostel and Jones and opened in 1914 as four dormitories and two fraternity houses. (HEC.)

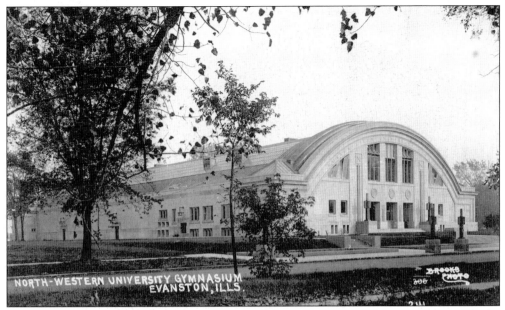

NORTHWESTERN GYMNASIUM. In 1909, when the Northwestern Gymnasium opened, the first event held there was the North Shore Music Festival. A gift from James A. Patten, it was always called Patten Gymnasium even though Patten would have liked otherwise. Designed by George Washington Maher in 1908, the building was made of Bedford limestone and pressed white brick. In addition to a gymnasium, there was also a baseball shed in the rear. When the gymnasium was built, it was the largest building of its kind in the Midwest. Patten Gymnasium was razed in 1940 for the Technological Institute. The above view is an undivided real-photo card showing Northwestern Gymnasium four years after its opening. The card below, postmarked 1913, shows a misleading title. However, the inside view of the gymnasium shows the steel, three-hinged arches that held up the roof and may be showing the view the night of the music festival. (VOH and CRC.)

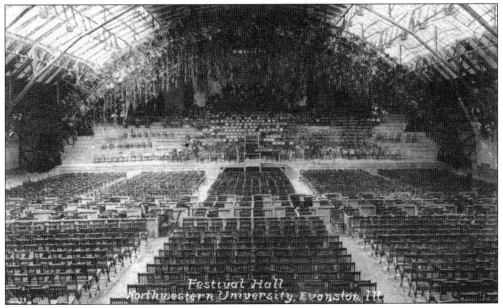

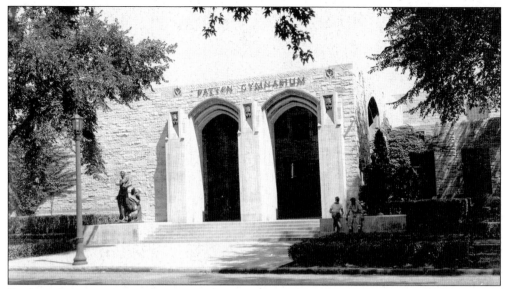

PATTEN GYMNASIUM. In the spring of 1939, a groundbreaking ceremony was held for a new gymnasium a few blocks north of the old gymnasium, on the southeast corner of Sheridan Road and Lincoln Avenue. Sculptor Herman MacNeil's bronze statues, known as *Pat* and *Jim*, which had formerly marked the entrance to the old gymnasium, now marked the entrance for the new building. The black and chrome doors from the old Patten Gymnasium were also installed in the new building, which would continue to be called Patten Gymnasium in honor of the Northwestern contributor and former mayor of Evanston James A. Patten. The new Patten Gymnasium was dedicated on November 2, 1940. The card above is postmarked 1945. The miniature postcard below belongs to a special set of 12 black-and-white photograph postcards enclosed in a small cardboard package ready for mailing by C. R. Childs. (LLC and CRC.)

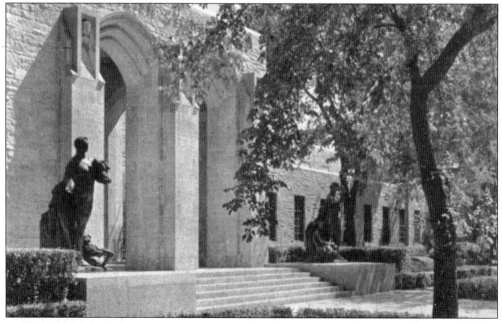

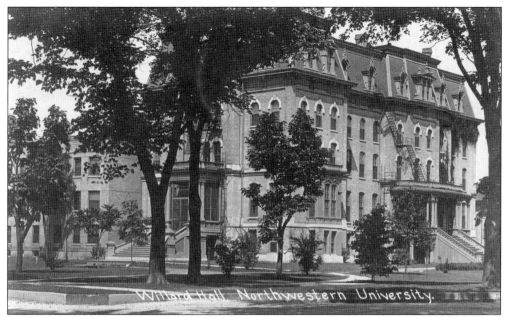

WILLARD HALL. In 1869, the Evanston College for Ladies was founded by a group of women to provide preparatory studies and a boardinghouse for female students. The school opened in the fall of 1871 with Frances E. Willard as president. A "Ladies' Fourth of July" event in 1871 raised $30,000, and the cornerstone for a new building, designed by architect Gurdon Randall, was laid. The above card shows the building after being renamed Willard Hall in 1901. Due to the Chicago fire in 1871, many donors were unable to fulfill their pledges, and by 1873, the Evanston College for Ladies merged with Northwestern University, which pledged $50,000 to finish construction. In 1874, the school reopened as the Woman's College of Northwestern University, also known as the "Fem Sem," with Willard as the first dean of women. The above and below cards are postmarked 1910 and 1945, respectively. (LLC.)

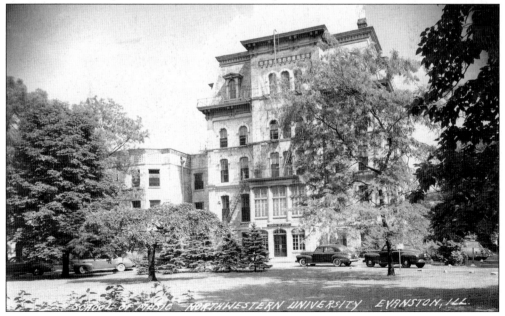

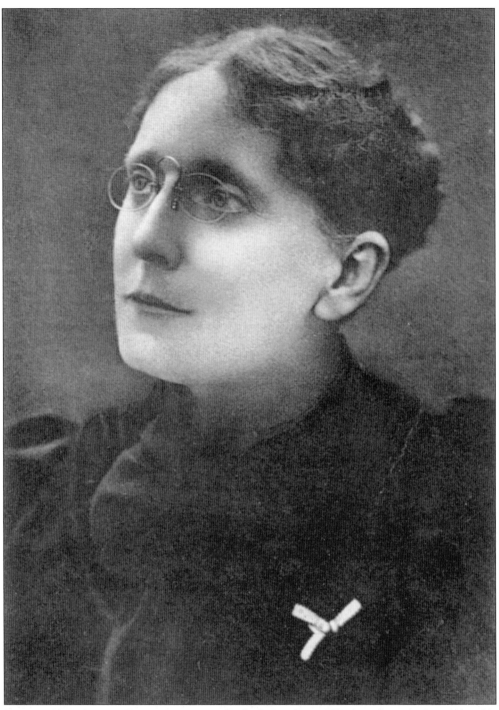

FRANCES ELIZABETH WILLARD. Frances Elizabeth Caroline Willard was born on September 28, 1839, in Churchville, New York. In 1858, at age 18, Frances and her sister Mary came to Evanston from Wisconsin to attend Northwestern Female College. She graduated in 1859 and began teaching at the Benson Avenue School and later at secondary schools in Pennsylvania and New York. (AMW.)

74

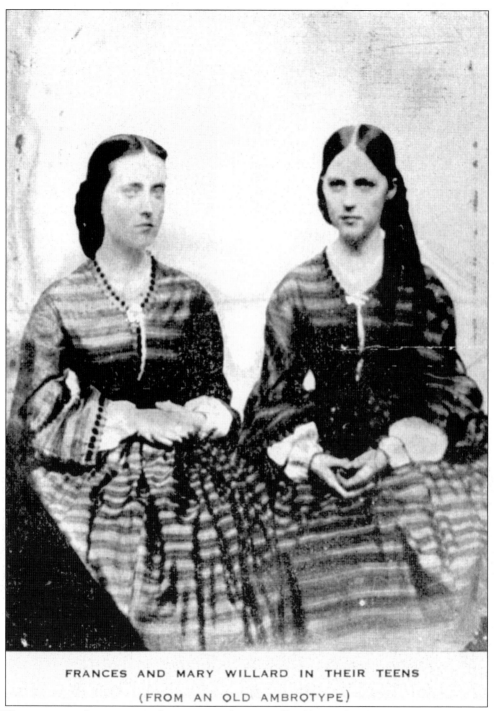

FRANCES AND MARY WILLARD IN THEIR TEENS

(FROM AN OLD AMBROTYPE)

WILLARD THE ACTIVIST. In the summer of 1874, Willard began to pursue a new career in the women's temperance movement. Her efforts for women's suffrage and temperance included a 50-day speaking tour in 1874 and an average of 400 lectures a year. She was elected president of the Woman's Christian Temperance Union (WCTU) in 1879. She fulfilled her dream of founding the world's WCTU in 1888 and was elected its president. (ECK.)

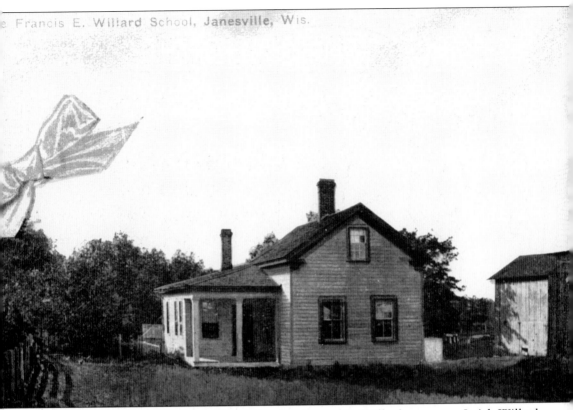

JANESVILLE, WISCONSIN, 1908. In 1846, when Frances E. Willard was seven, Josiah Willard and Mary Thompson Hill Willard moved their family to a southeastern Wisconsin farm on Rock River, near Janesville. Frances E. Willard spent most of her childhood in the family home that Josiah built. In addition, he built a frame schoolhouse in 1853, where she both went to school and later taught school. The Rock County WCTU acquired the site in 1921, and today it is used as a museum. (EBH.)

Let each one bring another.

Frances E. Willard.

Our White Ribbon Band is fighting hard
Against the curse of rum.
But there's an empty place for you—
We need you — won't you come?

Our next W.C.T.U. meeting will be
held at ..
Come early and get a hearty welcome

We Call To

WILLARD THE ORGANIZER. Ahead of everything, Frances E. Willard was an organizer. She organized for women through women. Under her leadership, the WCTU grew to be one of the largest organizations of women in the 19th century. She saw the WCTU as a "White Ribbon Army"—both as a way to accomplish reform and a means for training women to accomplish reform. This card is an example of an invitation to a WCTU meeting, it has an actual white ribbon attached with a straight pin. (LFP.)

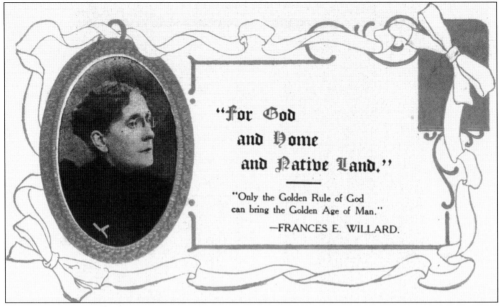

BEYOND TEMPERANCE, 1908. Frances E. Willard urged women to become involved in local and national politics, to advocate for the causes in which they believed, and to do whatever they could (as they were unable to vote) to create support for reform. She later saw the WCTU as part of a wider reform movement, especially regarding issues of women's suffrage and temperance. This card, postmarked 1908, has a gold, embossed raised frame with white ribbons. (FAO.)

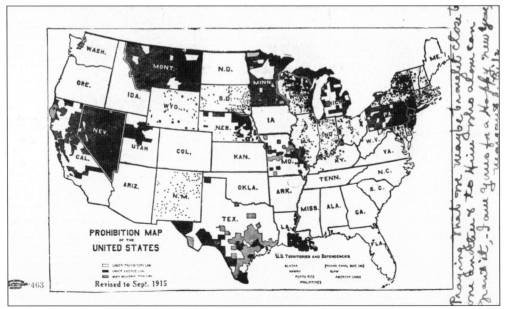

PROHIBITION MAP. The map shown was mailed in 1917 from a woman in Michigan who writes, "We have cause to rejoice from the great victory gained in Michigan during this year. This map will soon be changed, greater victories await us this year!" (WCTU.)

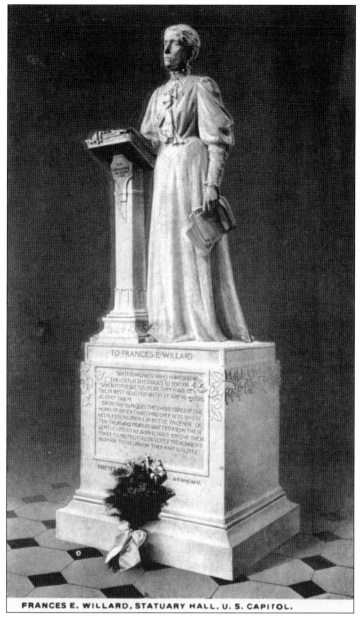

FRANCES E. WILLARD, STATUARY HALL, U. S. CAPITOL.

STATUARY HALL, WASHINGTON, D.C. The National Statuary Hall Collection in the United States Capitol is comprised of statues donated by individual states to honor notable persons in their history. Illinois being a state of many eminent men, made history and made itself proud when it chose Willard as the first woman ever to be included at the National Statuary Hall Collection. On February 17, 1905, Illinois governor Charles S. Deneen presented to the U.S. Congress a statue of Willard. The statue was sculpted of marble and made by Helen Farnsworth Mears (1878–1916) of New York City. Willard's influence was instrumental in the passage of the 18th (Prohibition) and 19th (women's suffrage) Amendments to the United States Constitution. She often said, "Alone we can do little, separated we are the units of weakness, but aggregated we become batteries of power. Agitate, educate, organize—these are the deathless watchwords of success." (BSR.)

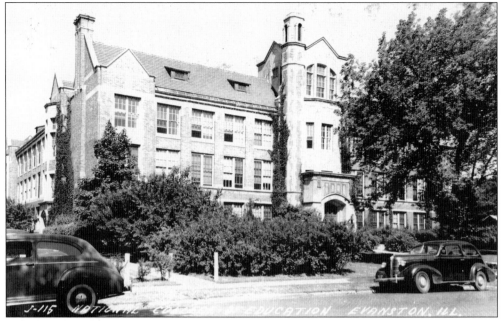

NATIONAL COLLEGE OF EDUCATION. Elizabeth Harrison, a pioneer in elementary and early childhood education, founded the National College of Education in 1886. The college moved from its location in Chicago to Evanston at 2770 Sheridan Road in 1926. The campus was on three and a half acres, and the main structure was known as Harrison Hall. The college prepared teachers to teach nursery school, kindergarten, and elementary school. The building was demolished in 2006. (LLC.)

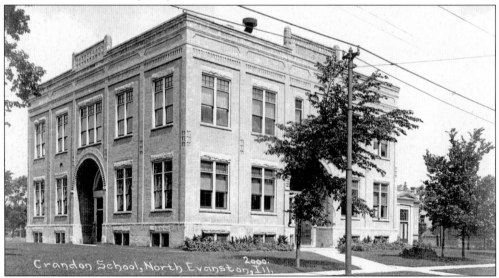

CRANDON SCHOOL. Built in 1893–1894 on the northeast corner of Central Street and Stewart Avenue, this site is presently known as Independence Park. Following 26 years of service to District 75, Frank Phillip Crandon (1834–1919) retired in 1915, and the school was renamed in his honor. Designed by William C. Pocklington, the two-story brick building had eight classrooms. The school closed in 1927, and students were transferred to the new Haven School on Prairie Avenue. This card is postmarked 1910. (CRC.)

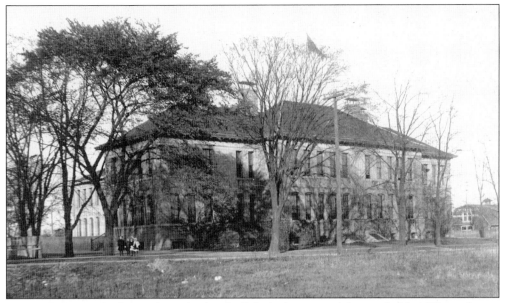

NOYES SCHOOL. At the northern dead end of Maple Avenue and the north side of Noyes Street, D. H. Burnham designed Noyes Street School in 1892 for School District 1. The two-story building was made of Milwaukee brick and cost $35,000 to construct. In 1949, an auditorium and gymnasium were added. Noyes School closed in 1976 and District 65 leased the building to the Noyes Cultural Arts Center. The city bought the property in 1980, and the Evanston Arts Council uses the building today. This card is postmarked 1912.

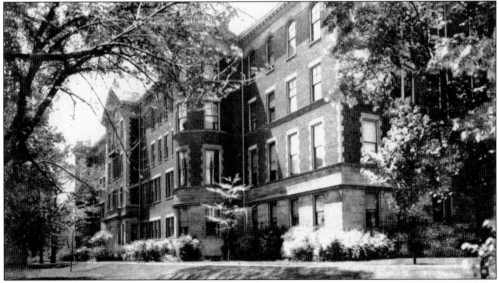

MARYWOOD SCHOOL. Built in 1900–1902 as the Visitation Academy and designed by John Henry Schlacks (1868–1938), the school was taken over by St. Mary-of-the-Woods and incorporated as the Marywood School for Girls in 1917. The city later bought the property and moved from the municipal building at 1501 Oak Avenue into the Evanston Civic Center, 2100 Ridge Avenue. Evanston residents voted in an advisory referendum on April 17, 2007, to keep city offices in the civic center and rehab the building. While debate continues, the fate of the building remains undetermined. (AC.)

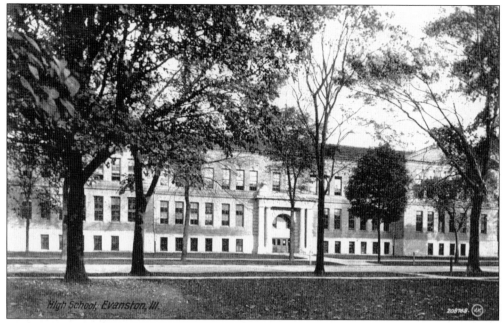

HIGH SCHOOL. Ground was broken on October 18, 1882, for Evanston Township High School at the southeast corner of Benson Avenue (now Elmwood Avenue) and Dempster Street. The building was remodeled in 1899 by Charles Robert Ayars (1861–1934). This card postmarked 1910 shows the red pressed brick with terra-cotta and limestone trim used in the rehab. (SHK.)

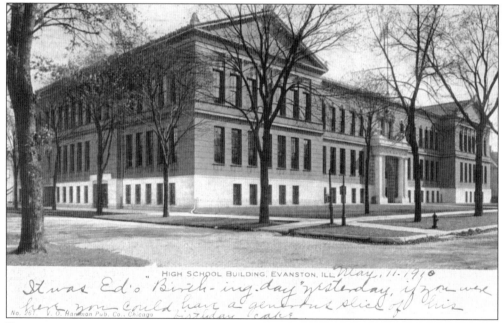

DEMPSTER STREET AND BENSON AVENUE, HIGH SCHOOL. The school board acquired property on Dodge Avenue in 1922 and sold the building on Dempster Street to Districts 75 and 76. The building was used as a middle school and was renamed the Boltwood Intermediate School in honor of Henry Leonidas Boltwood (1831–1906). Three years later, the building was destroyed by fire. This card is postmarked 1910. (VOH.)

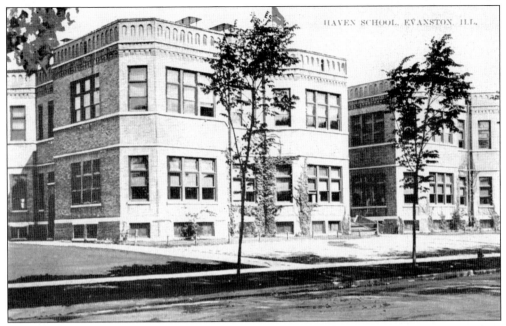

HAVEN SCHOOL. Built to replace the Benson Avenue School, a new school was constructed on the northwest corner of Church Street and Sherman Avenue. Designed by Burnham and Root and constructed by Charles T. Bartlett of cream-colored brick, the school was named after Otis Erastus Haven (1849–1888), who had served as superintendent from 1873 to 1882. This card is postmarked 1913. (S.)

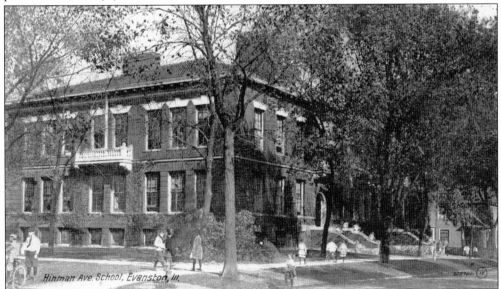

HINMAN AVENUE SCHOOL. Designed by D. H. Burnham and Company and built in 1898, the redbrick building trimmed with white terra-cotta on the northeast corner of Hinman Avenue and Dempster Street was called the Hinman Avenue School. It was renamed to honor Humphreys Henry Clay Miller (1845–1910), who served as president of the District 75 school board from 1891 until his death. This view, postmarked 1914, looks east from Dempster Street. The building has housed Chiaravalle Montessori School since 1980. (V.)

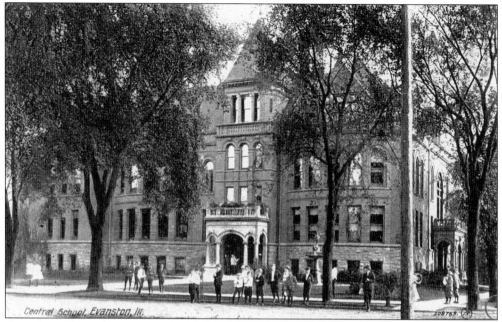

CENTRAL SCHOOL. At a cost of $18,000, a four-room, brick building was built on Lincoln Avenue (now Main Street) and Benson Avenue (now Elmwood Avenue) in 1871 and called Central School. A fire broke out while school was in session during 1893. There were some injuries, but no one was killed, due to the heroic efforts of Jenny Foster, a first-grade teacher. This card is postmarked 1910. (SHK.)

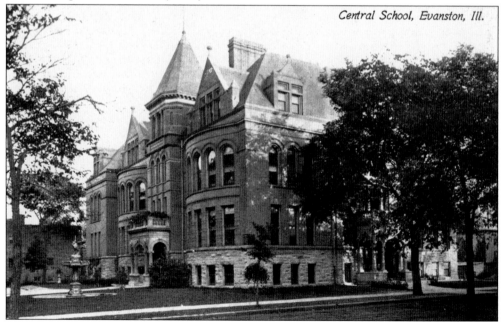

CENTRAL SCHOOL SHOWING FOUNTAIN. Another hero during the fire was Sam Mack, who ran an express business in the south end of town; he caught several of the children who jumped from the burning building, saving them from death. The fountain shown in this real photograph was erected in 1901 as a memorial to the bravery of the people who rescued the children. (VOH.)

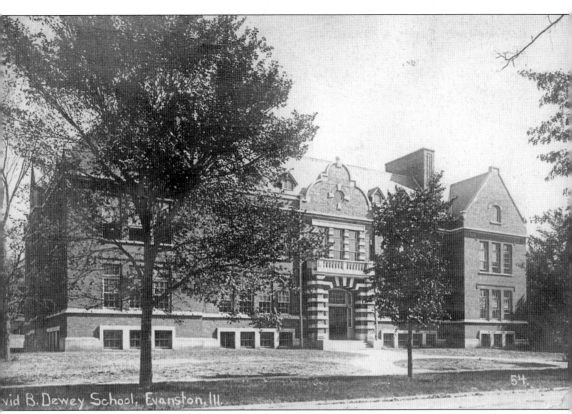

vid B. Dewey School, Evanston, Ill.

DEWEY SCHOOL. This real photograph was taken after the second Dewey School was built. The first Dewey School named for David Brainard Dewey (1841–1898) was constructed in 1881 for District 1 to serve children "on the ridge." Located on the northeast corner of Wesley Avenue and Grove Street, the first school was too small and required an addition in 1889. By 1905 the city's health commission closed the school due to overcrowding. The new Dewey School shown in the photograph was built in 1906. (CRC, courtesy of the Evanston History Center.)

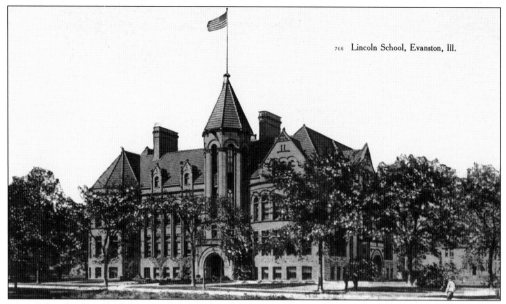

766 Lincoln School, Evanston, Ill.

LINCOLN SCHOOL. Lincoln School was built to replace Central School in 1895–1896 on the northwest corner of Main Street and Forest Avenue. Designed by J. T. W. Jennings, the building had more elaborate details throughout than did Central School. The base was built of Joliet limestone with Bedford limestone trim, and red oak was used throughout the interior. Over the Main Street entrance, there was a 72-foot-high tower that had extensive terra-cotta ornamentation. The building was demolished in 1968. (CT.)

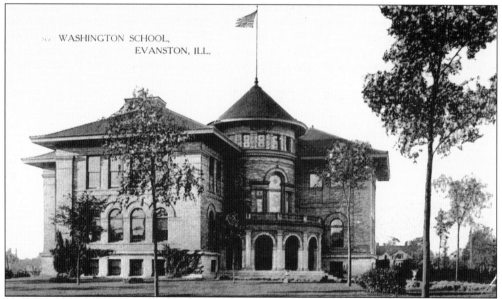

WASHINGTON SCHOOL,
EVANSTON, ILL.

WASHINGTON SCHOOL. The District 2 school board voted in 1899 to hire Patton, Fisher and Miller to design a new school for the west side of the district. Washington School opened on George Washington's birthday, February 22, 1901. The two-story building was built of Roman pressed brick and trimmed in Bedford limestone. Washington School is still located on the northwest corner of Main Street and Ashland Avenue and remains in use in School District 65. This card is postmarked 1908.

86

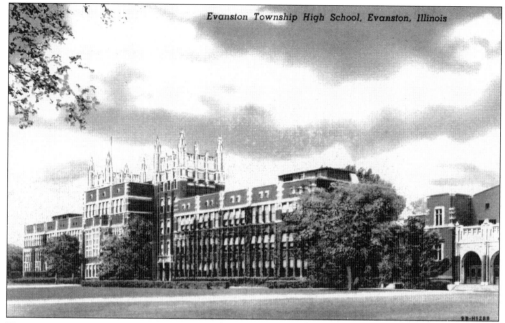

EVANSTON TOWNSHIP HIGH SCHOOL, 1600 DODGE AVENUE. A battle ensued over the location of the new Evanston Township High School in 1915. One side campaigned for the southwest corner of Ridge Avenue and Lincoln Street. The opposition preferred a site that spanned from Asbury Avenue to the west side of Ashland Avenue. An election was held, and not only was there a recount, but the election went on to the Illinois Supreme Court, which set aside the results of the election in April 1919. A compromise was offered by the school board for a 55-acre site on Dodge Avenue between Church and Lake Streets. On October 11, 1919, voters preferred the Dodge Avenue site to the old Ridge Avenue location and later authorized a million-dollar bond issue for the new building. Designed by Perkins, Fellows and Hamilton, plans were approved in 1922, and ground was broken on January 2, 1923. The school opened for fall classes in 1924. (CT, JOS, and ECK.)

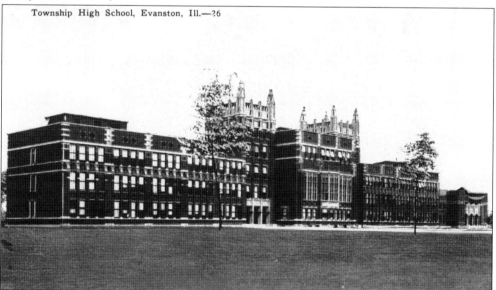

Township High School, Evanston, Ill.—26

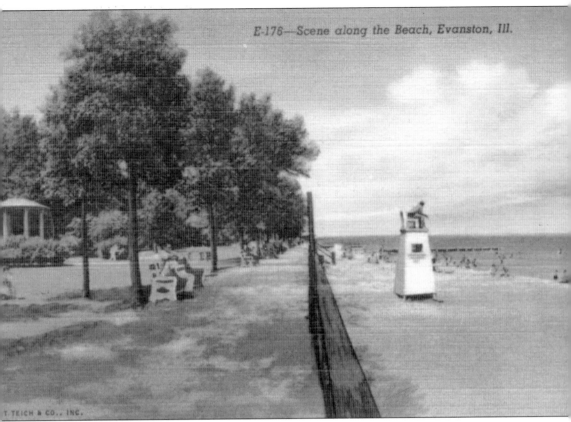

This card shows an Evanston beach around 1940. (CT.)

Six

LAKEFRONT

AND RECREATION

During the mid-1850s, three Lake Front Parks were allocated along Lake Michigan's shore in newly platted Evanston. The first, containing 15 acres, extended from University Place (Sheridan Road) to Greenwood Boulevard (Street). The second Lake Front Park, with just more than one and a half acres, continued from Greenwood Boulevard (Street) to Hamilton Street. The third Lake Front Park was from Greenleaf Street to Lee Street, encompassing one and a quarter acres.

On September 8, 1860, one of the worst shipwrecks on record then, that of the *Lady Elgin*, occurred and highlighted the need for a Coast Guard station. A side-wheeler steamer, the largest and finest on the lake, was carrying 393 passengers on a sightseeing trip. The vessel collided with a lumber schooner, the *Augusta*. Northwestern University students gathered on the shore to help, and one specific young man, Edward W. Spencer, went back into the angry waves of the nor'easter many times to rescue at least 17 people. He was rewarded for his efforts by the City of Evanston, when it awarded him a gold watch in recognition of his heroic lifesaving. In addition, a bronze tablet given by Northwestern University's class of 1898 commemorating his service was installed in Patten Gymnasium.

The Sheridan Road Association was established in 1889 by Evanston resident Volney W. Foster (1848–1904), who had long sought to complete Sheridan Road as a scenic route from Chicago to Milwaukee. The "Father of Sheridan Road," he helped to secure the legislation necessary to reclaim land from the lake and to establish parks along the drive. Sheridan Road, named for Gen. Philip Henry Sheridan (1831–1888), was established in Evanston in 1892. The project took years of planning and required the cooperation of property owners and municipalities along the road. Finally, on September 26, 1916, named Sheridan Road Day, 1,500 people gathered at the Illinois-Wisconsin border with a parade of automobiles to pledge the completion of the road. The Evanston Small Parks and Playgrounds Association presented a plan to the city council in 1917 that would not only beautify the parks, but the entire city.

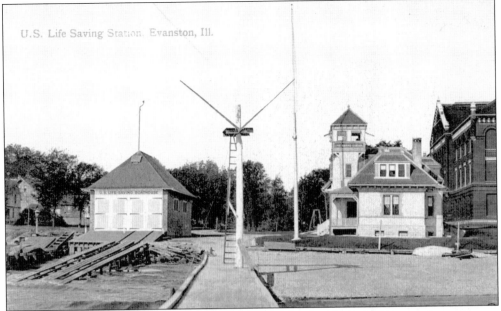

LIFESAVING STATION. As a result of student participation after the *Lady Elgin* wreck, a volunteer lifesaving crew of five men from the senior class of Northwestern University was organized in 1872. Commodore Murray, responsible for the U.S. Lifesaving Service, presented a lifeboat to Dr. Erastus O. Haven. Initially the boat was stored on the beach. Looking west, this card shows the U.S. Coast Guard and Fisk Hall on the right. During 1876–1877, work began on the U.S. Lifesaving Station east of Old College, and a boathouse was built on the site near where Fisk Hall is shown. The modern English Gothic coast guard building had a limestone base with brick walls. In 1915, the volunteer service was combined with the Lifesaving Service to create the U.S. Coast Guard. (SHK and VOH.)

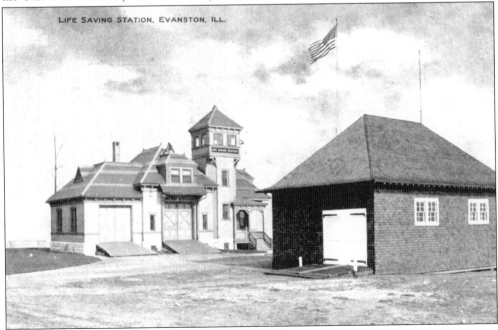

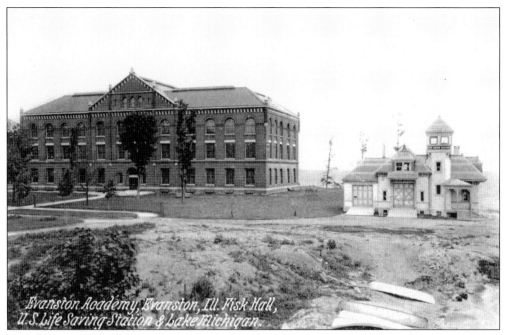

FISK HALL, U.S. COAST GUARD. This view shows the boathouse had yet to be moved to its new location shown in the photographs on the previous page. In 1899, to accommodate Fisk Hall, the boathouse was moved to newly made land near the water's edge. Due to rising lake levels and erosion, the U.S. Coast Guard recommended closing the Evanston station in 1929. It moved to Wilmette in 1931. (RC.)

EVANSTON ACADEMY IN WINTER. This real photograph is showing the view behind the academy, or Fisk Hall looking south after a snowfall. (RC.)

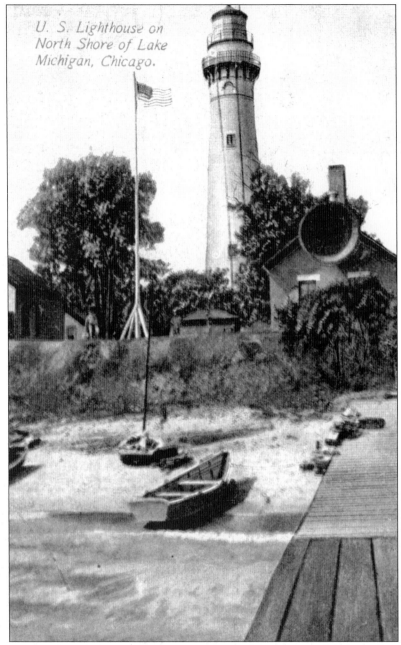

U. S. Lighthouse on North Shore of Lake Michigan, Chicago.

LIGHTHOUSE, SHOWING FOGHORN. Having approved a new coastal light in Evanston, the United States government purchased land in 1871 on Grosse Pointe. Designed by Orlando M. Poe, engineer of the Upper Lakes Lighthouse District, the lighthouse would include a two-and-a-half-story house with eight rooms, a full basement, and an adjoining woodshed. Built by W. F. Bushnell of Chicago, the conical-shaped tower was completed in 1874. In 1914, a coating of concrete three and a half inches thick was added to the tower. At times, fog would obscure the light; therefore, a fog whistle system was installed in 1880. The whistle sounded blasts lasting five seconds each with alternate intervals of 20 and 40 seconds. This card incorrectly states that this Evanston lighthouse and foghorn are in Chicago. This card is postmarked 1912.

DAVIS STREET, LAKE FRONT PARK, LOOKING SOUTH. The Davis Street Pier was built just to the east and north of this view by the Evanston Pier Company, which was incorporated in 1857. William H. Judson and J. M. Hill built the pier of heavy planking, 50-feet wide and a mile into the lake. This real photograph, postmarked 1909, shows Lake Front Park looking south and showing the lagoon.

LAGOON, SOUTHWEST PARK VIEW. The land along the Lake Michigan shore was full of brush and a tangle of burrs in 1894. In 1911, Charles Gates Dawes, James A. Patten, and William A. Vawter donated the land at Greenwood Street and the lake for a park. This photograph, postmarked 1910, is taken from the eastern side, looking southwest with Greenwood Street to the left and Sheridan Road on the horizon. (CRC.)

LAKE FRONT PARK VIEW LOOKING NORTH. Benjamin F. Housel (1833–1918), superintendent of streets began filling in the lakefront with garbage, ashes, and street sweepings. This effort saved the city the cost of hauling refuse, and with the addition of dirt, trees, and grass, this Lake Front Park between Clark Street and Greenwood Street was beautiful by 1905. By this time a WPA-type program to provide work for Evanston's poor had slowly removed the Davis Street Pier. (PLH.)

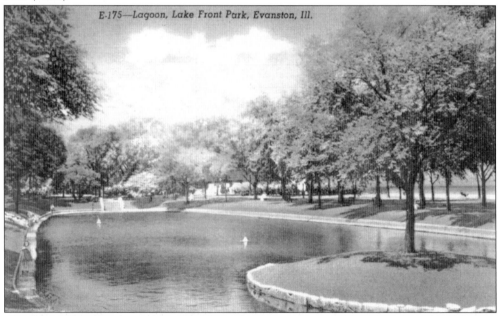

LAGOON, LOOKING NORTH. This more recent, although still vintage view of the lagoon, postmarked 1950, shows growth of the elm trees thoughtfully planted; also the recreation buildings can now be seen in this view of the lagoon. A new waterfall was installed on the west side of the lagoon and dedicated in memory of Evanston resident Jim Purnell (1941–2003) on October 20, 2007. Today the City of Evanston is considering several plans to modify the present lakefront park system. (CT.)

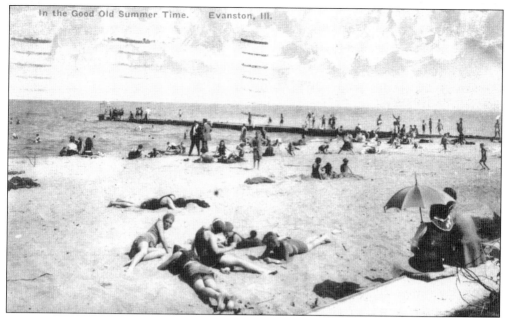

In the Good Old Summer Time. Evanston, Ill.

SUMMERTIME AT THE BEACH. Evanston's lakefront has long been an attraction, and this beach view was as common in 1928 as it is today. Erosion of the lakeshore had become an increasing concern. In this postcard, the view is southeast looking at a breakwater. A few beachgoers are seen sitting on a concrete ledge in the foreground. The rocks that line today's lakefront and are being considered for removal are located on top of that ledge. This card is postmarked 1928. (HEC.)

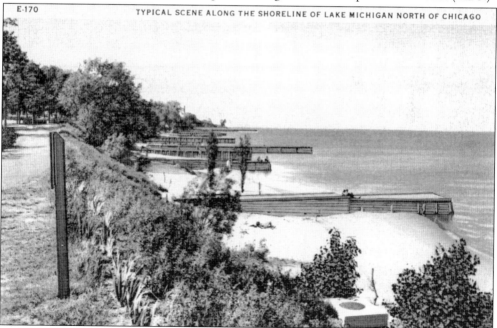

E-170 TYPICAL SCENE ALONG THE SHORELINE OF LAKE MICHIGAN NORTH OF CHICAGO

LAKE SHORE SCENE, C. 1912. The exact location of the view shown in this postcard is not known, although a guess would be the view is looking north. On the back the sender writes, "This was evidently taken when we had the drive along the lake and park, which washed away and was never rebuilt." (CT.)

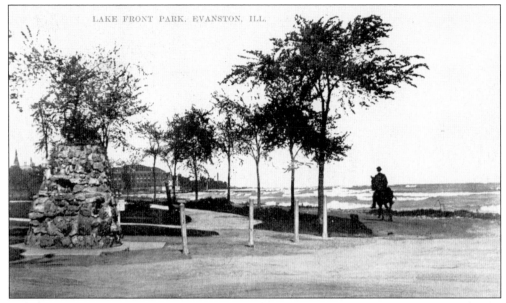

LAKE MICHIGAN AT CLARK STREET. The rising lake levels were continuing to overtake the lakeshore, and the city built a new seawall at Calvary Cemetery to try and protect the newly constructed Sheridan Road. In 1927, in an effort to retain the U.S. Coast Guard, the city began a plan for redevelopment of the lakefront, to no avail. This card postmarked 1910 shows the view from Clark Street looking north, with the man on a horse headed toward Fisk Hall in the distance.

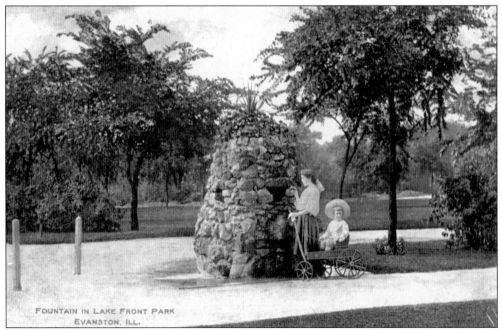

WOMAN WITH CHILD AT FOUNTAIN. This view of a woman and a child at the fountain at Clark Street is looking south. The card postmarked 1911 is but one of many examples in the collection that show young elm samplings brought from the Big Woods in north Evanston to shade the lakefront. (VOH.)

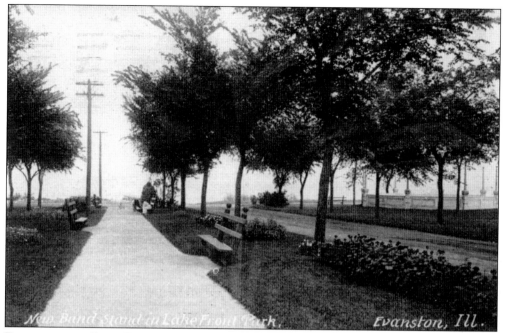

New Band Stand in Lake Front Park, Evanston, Ill.

BANDSTAND IN LAKE FRONT PARK. These two cards together show both entry and departure from Lake Michigan at Clark Street. In the view above, postmarked 1915, the photograph shows the fountain at the east end of the walk on the right, and further to the right is the new bandstand built north of Davis Street Pier. The view below, postmarked 1911, looks west from the fountain and shows the walkways in Lake Front Park. (VOH and SHK.)

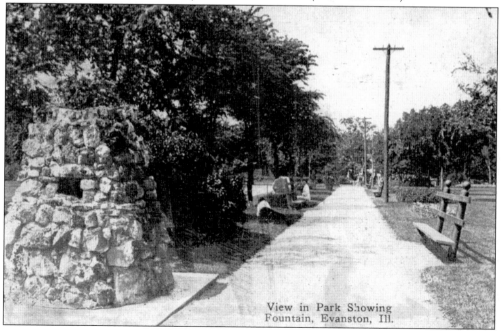

View in Park Showing Fountain, Evanston, Ill.

LAKE FRONT PARK, EVANSTON, ILL.

LAKE FRONT PARK, *C.* **1906.** This next postcard puts the viewer in about the same location as the previous two cards; only now, the view is looking north from the park toward Fisk Hall. The card below shows the walk along the lake near campus south of Clark Street and shows the piers or jetties along the lakefront, similar to those shown on page 95. These small piers were eventually washed away. (VOH.)

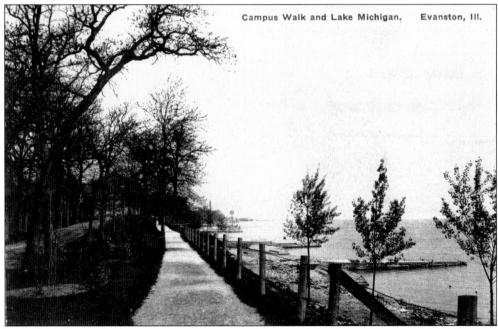

Campus Walk and Lake Michigan, Evanston, Ill.

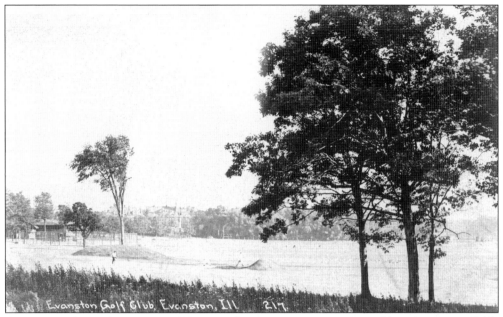

Evanston Golf Club, Evanston, Ill. 217

EVANSTON GOLF COURSE. In 1924, as today, just one community golf course was available within the city limits. The course that stretches along both banks of the North Shore Channel, north and south of Central Street, is on 60 acres of Metropolitan Water Reclamation District land that is leased to the City of Evanston and Wilmette. The course was developed by Peter N. Jans and a group of friends in 1916 and was named after Jans in 1919. Their goal was to make golf affordable for the common man. The Frank Govern Family Foundation has given a donation to improve the course conditions, and beginning in 2008, the course will be renamed the Frank Govern Memorial Golf Course. The above view, postmarked 1910, shows the grounds with the clubhouse in the far distance, and below, postmarked 1911, a closer view of the clubhouse is shown. (CRC and S.)

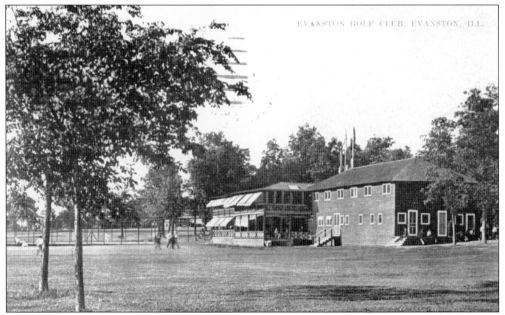

EVANSTON GOLF CLUB, EVANSTON, ILL.

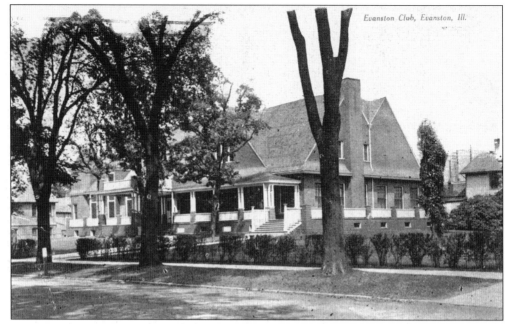

EVANSTON CLUB. At a meeting held at the Hotel Richelieu in Chicago, 15 Evanston residents founded the Greenwood Club on November 24, 1888. Rules and bylaws were adopted, and Marshall M. Kirkman was elected president. Admission was set at $300 with $50 annual dues. The club purchased the former Ludlam property at the northwest corner of Chicago Avenue and Grove Street. The club changed its name to the Evanston Club on January 14, 1889, and approved plans designed by William Holabird, an Evanston resident of the architectural firm of Holabird and Roche. The above and below cards are postmarked 1909 and 1947, respectively. (TJ and VOH.)

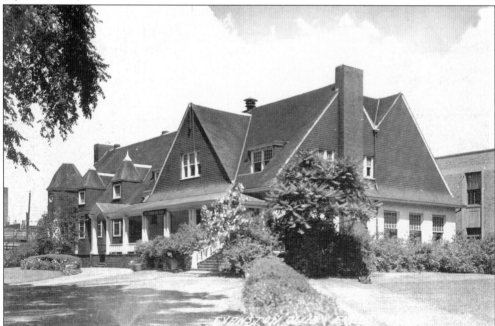

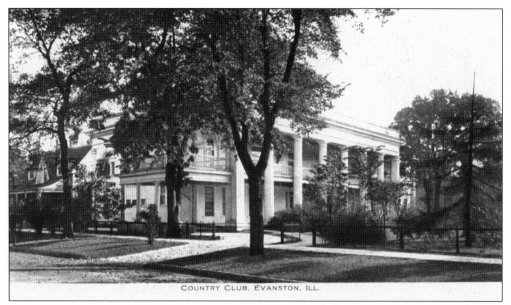

COUNTRY CLUB, EVANSTON, ILL.

COUNTRY CLUB. The Evanston Country Club was organized at the home of Marshall M. Kirkman on May 14, 1888, and in March 1889, Kirkman was elected its first president. The club built a single-story, open-room structure with a brick fireplace and a high ceiling named the Shelter on the southeast corner of Hinman Avenue and Clark Street. The club purchased property on the northeast corner of Lake Street and Oak Avenue, and Holabird and Roche designed a new building. The structure was a two-story frame building, with its entrance on Oak Avenue and a Doric colonnade on the Lake Street side. The Shelter was moved to the site in 1892. The club had many activities for both ladies and gentlemen, and membership fees were $5. Polo, cycling, baseball, tennis, and theater were offered "for the purpose of making life in Evanston even more pleasant." The card above is postmarked 1906, and the card below is postmarked 1908. (VOH and TJ.)

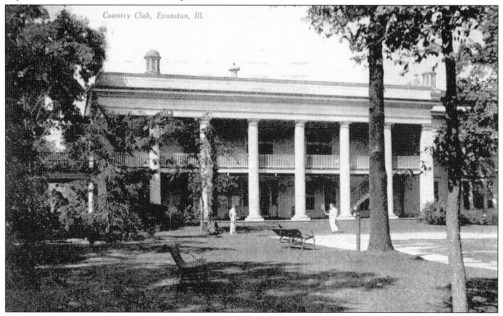

Country Club, Evanston, Ill.

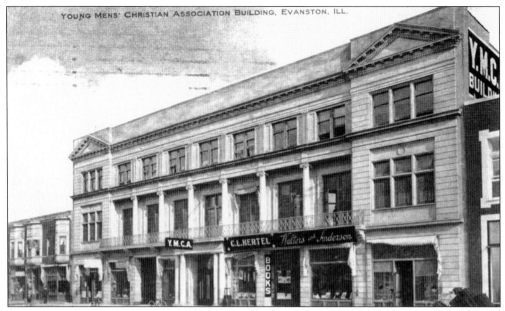

YOUNG MEN'S CHRISTIAN ASSOCIATION. The YMCA was incorporated on November 17, 1885, and Mathew P. Aiken was elected the first president. It was located in the 1576 Sherman Avenue building until 1893. In 1898, the organization bought the property at 1611–1621 Orrington Avenue and Holabird and Roche designed a new building. In 1910, of the 8,000 YMCA organizations in the world, 2,000 were in North America, and one was in Evanston. This card is postmarked 1908. (VOH.)

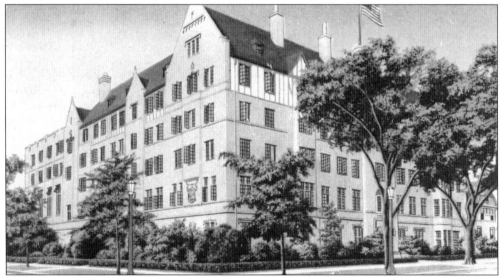

THE NEW YMCA. In 1925, the YMCA purchased property at the southwest corner of Maple Avenue and Grove Street for a new structure. The cornerstone was laid on May 20, 1929. Designed by Chester Howe Walcott (1833–1947), the grand opening was held on New Year's Day 1930. The new, 238-room building had two gymnasiums, exercise rooms, a 75-foot swimming pool, handball and squash courts, and a self-service grill. The Gothic building seen in this card postmarked 1939 received an award in 1929 from the Evanston Art Commission and today is known as the McGaw YMCA. (MWM.)

Seven

CHURCHES

In the early days of Ridgeville, the Baptists, Catholics, Methodists, and Presbyterians came together in the meetinghouse at present-day Greenleaf Street and Ridge Avenue, the log schoolhouse built near 1841 on the ridge. The first Sunday school was started in the Mulford house but moved to the log house in the mid-1850s.

The first church building in newly platted Evanston was built in 1856 on the northeast corner of Orrington Avenue and Church Street for $2,800, the present site of the Evanston Public Library. This church was a community church used by all denominations, although owned by the Methodists. The small, frame building with green shutters served for 16 years. In 1881, it was moved to Sherman Avenue and Church Street and became the Norwegian-Danish Methodist Episcopal Church.

During 1867–1869, plans were drawn to build the First Methodist Episcopal Church on the southwest corner of Hinman Avenue and Church Street. The only commencement services ever held for the Evanston College for Ladies were held in the basement of the unfinished church in June 1872. The first services held in the church were to give a farewell to Dr. Henry M. Kidder and his family in August 1872.

In 1858, the Baptists, who worshiped with the Methodists for more than 10 years, were now planning for the Evanston Baptist Church. Francis M. Iglehart was known as the "Mother of the Baptist Church," as she had for many years held Sunday school at her home. In 1875, the name was changed to First Baptist Church of Evanston, and the new building at the northwest corner of Chicago Avenue and Lake Street was dedicated.

On December 8, 1859, the First Congregational Church was organized. Eight women and three men made up the members of the church. Until 1868, members were using the church on the southeast corner of Lake Street and Chicago Avenue together with the Presbyterians. The Gothic Revival church on the east side of Hinman Avenue between Lake and Grove Streets cost $25,000 to build. During 1883, the church finished the basement and later enlarged the auditorium. However, the building was destroyed by fire on November 24, 1884.

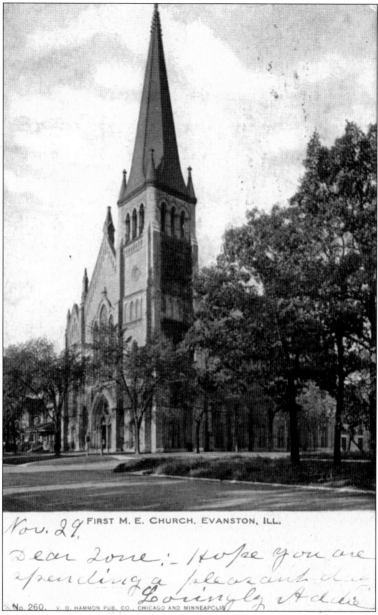

FIRST M. E. CHURCH, EVANSTON, ILL.

Nov. 29,

Dear Zone:- Hope you are
spending a pleasant day
Lovingly Addie

No. 260. V. O. HAMMON PUB. CO., CHICAGO AND MINNEAPOLIS

FIRST METHODIST EPISCOPAL CHURCH. Although the church had its beginnings in the small church on Orrington Avenue and Church Street that was shared by many denominations, the Methodists were ready for their own building, and the cornerstone was laid at the new site on the southwest corner of Hinman Avenue and Church Street on Independence Day 1870. The Chicago fire interrupted the construction of the building, designed by Cass Chapman of Chicago. The building was completed in 1874; however, the spire was not complete until 1887. The building had numerous problems that were checked by other architects, Edward Burling in 1879 and William W. Boyington in 1880. By 1909, the church closed for repairs, and it was determined that a new building would be built in its place. This card postmarked 1906 shows the First Methodist Episcopal Church built at Hinman Avenue and Church Street looking southwest. (VOH.)

FIRST METHODIST. The new First Methodist Episcopal Church was designed by church member Thomas Eddy Tallmadge (1876–1940), of Tallmadge and Watson, and dedicated in October 1911. During the interim, church services were held at Fisk Hall and sometimes the music hall of Northwestern University. This card is postmarked 1949. (LLC.)

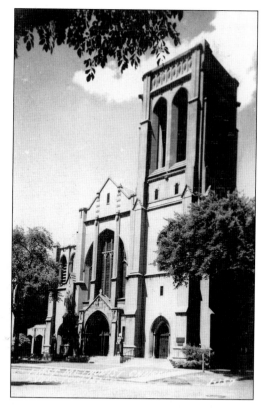

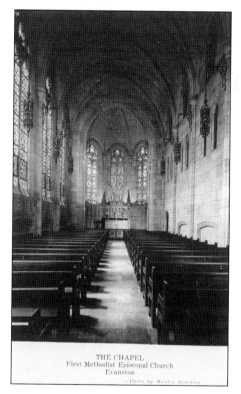

THE CHAPEL
First Methodist Episcopal Church
Evanston
—Photo by Wesley Bowman

FIRST METHODIST EPISCOPAL CHAPEL. In 1930, Tallmadge oversaw alterations to the building, including new stained-glass windows, the western rose window set in stone tracery, and the addition of the chapel. Ralph Adams Cram (1863–1942) designed the oak reredos, and Irving and Casson of Boston carved them. This real photograph is showing the inside of the chapel. (WB.)

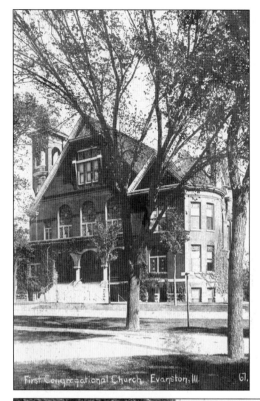

FIRST CONGREGATIONAL CHURCH. This real photograph, postmarked 1907, shows the view from the Lake Street vantage point looking east at the First Congregational Church. The eastern border for Raymond Park, it was located on the east side of Hinman Avenue, between Lake and Grove Streets. Designed by Gabriel Isaacson to replace the previous building lost to fire in 1884, the new building was built of red pressed brick with Bedford limestone trim and dedicated on April 11, 1886. (CRC.)

First Congregational Church, Evanston, Ill. 67.

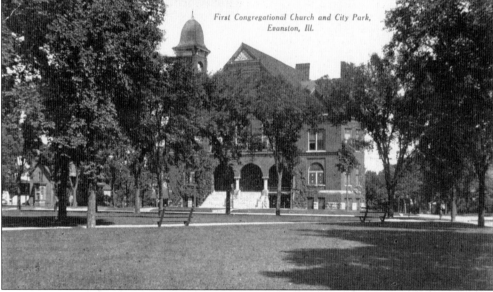

First Congregational Church and City Park, Evanston, Ill.

CHURCH AND RAYMOND PARK. This card postmarked 1908 shows a wider eastern view and is taken from the middle of Raymond Park, with Lake Street on the right and Grove Street on the left. The building contained a semicircular balcony, and a two-story auditorium that included stained-glass windows designed by George A. Misch and Brothers. In 1927, Tallmadge and Watson designed a new building (not shown), which was the third and present building at that location for the First Congregational Church. (TJ.)

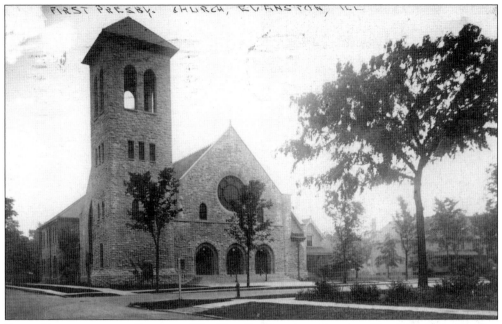

FIRST PRESBYTERIAN CHURCH. The First Presbyterian Church suffered the loss of its first building on the southeast corner of Lake Street and Chicago Avenue. D. H. Burnham and Company designed a new Gothic Renaissance church in 1894, notable for the 120-foot tower built of Lemont limestone. This real photograph, postmarked 1930, puts the viewer on the northwest side of Lake Street looking east. Harry Bergen Wheelock designed the narthex and parish house. (PLH.)

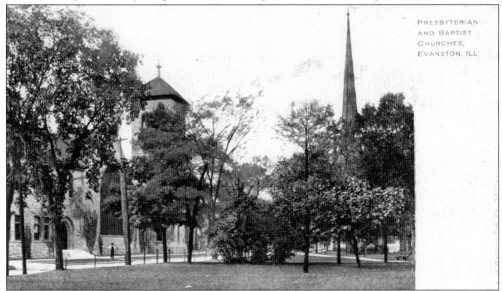

FIRST PRESBYTERIAN AND BAPTIST CHURCHES AND RAYMOND PARK. The area bounded by Hinman and Chicago Avenues and Lake and Grove Streets is 1.9 acres. In 1901, Raymond Park was named in honor of Rev. Miner Raymond, pastor of the First Methodist Episcopal Church. Reverend Raymond's home was on the present site of the Georgian. This card postmarked 1915 shows Chicago Avenue and Lake Street from Raymond Park with the view looking southwest. (VOH.)

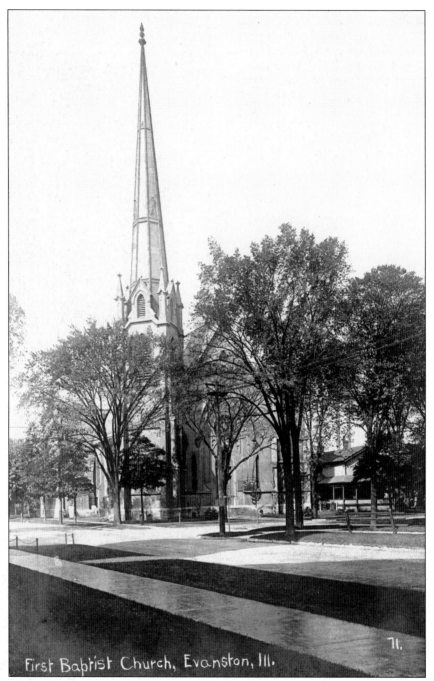

First Baptist Church, Evanston, Ill.

71.

BAPTIST CHURCH. Another real photograph, postmarked 1906, shows the Evanston Baptist Church and completes the views from various vantage points surrounding Raymond Park with church buildings that are still present today. This card is looking northwest at the intersection of Lake Street and Chicago Avenue. Edward H. Mulford and others founded the Evanston Baptist Church, and early services were held in a building near Ridge Avenue and Oakton Street, known as the Oakton Chapel. In 1872, the church hired Chicago architect Cass Chapman to design a new building. Today the building survives and is known as the Lake Street Church. (CRC.)

NEW EBENEZER CHURCH. The Reverend George H. Hann organized the Ebenezer African Methodist Episcopal Church in 1882. Designed by Asa Lyon, the congregation built a small frame church on Benson Avenue north of Clark Street that burned down in 1907. A new church designed by Charles R. Ayars was planned for the north side of Emerson Street between Ridge and Maple Avenues and completed on March 21, 1909.

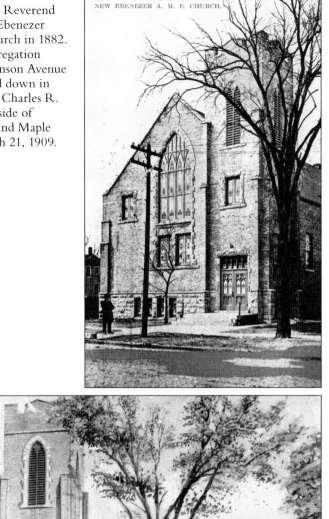

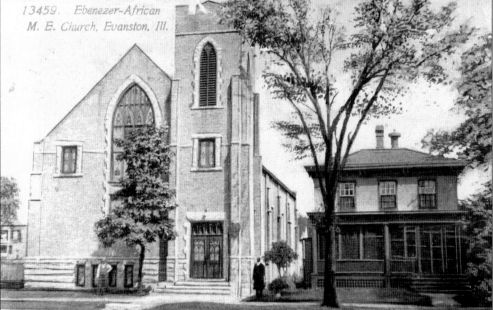

EBENEZER AFRICAN METHODIST EPISCOPAL CHURCH. The church suffered another fire near its centennial, on December 23, 1980. Severe damage to the two organs, the sanctuary, and the choir loft of the church led to restoration that was completed in June 1982. This card, postmarked 1917, shows the house next door to the east, which is no longer there. (AC.)

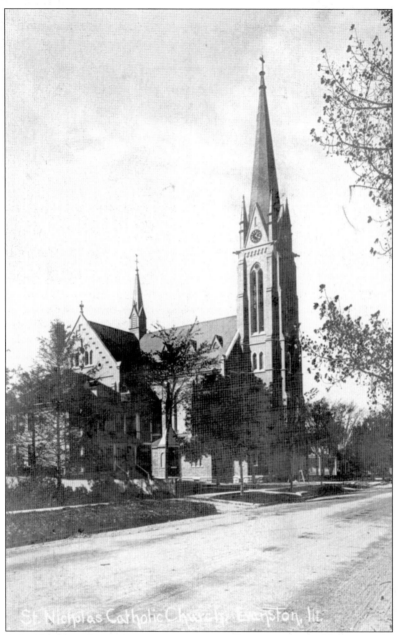

ST. NICHOLAS ROMAN CATHOLIC CHURCH. On July 20, 1887, Archbishop Patrick Feehan (1829–1902) established St. Nicholas Roman Catholic Church and named Fr. Otto Groenenbaum as first pastor. Property at the southwest corner of Ridge Avenue and Washington Street was acquired, and in September, construction began on the church building. During school hours in 1897, the school caught fire, and it spread to the church building, which burned down completely in two hours. In 1898, a new school, the current "old" school and social hall building, was built, and masses were held in the chapel. Fr. Peter "Leo" Biermann was the pastor. Ground was broken on September 5, 1904, for a new church building, and in December on St. Nicholas Day, the cornerstone was laid. The first mass in the current church building was celebrated on October 7, 1906. (CRC.)

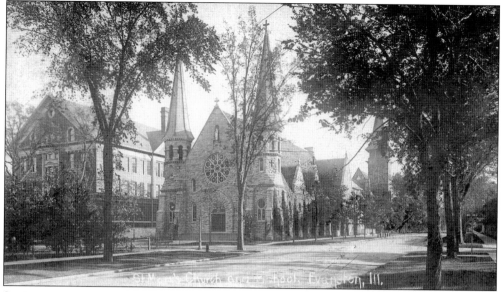

ST. MARY'S ROMAN CATHOLIC CHURCH. The O'Leary family came to Evanston in the 1830s and settled on land near the present site of Calvary Cemetery. A story is told that the first Catholic mass in Evanston took place near the entrance to Calvary Cemetery on the O'Leary property under a huge oak tree in 1864. The lore is that the tree later served as a massive table and altar at St. Mary's Roman Catholic Church, although evidence of the table is no longer available. Local parishioner and architect Steven A. Jennings designed St. Mary's Roman Catholic Church. The building was made of Lemont limestone and completed on the southeast corner of Lake Street and Oak Avenue in 1891–1892. The 100-foot-tall spires were inspired by St. Patrick's Church in Pennsylvania. These two images of St. Mary's Roman Catholic Church and School show nearly the same photograph. The above card, postmarked 1907, is a real-photo card, and the postcard below, postmarked 1911, shows the pressed red brick of the school building. (CRC and SHK.)

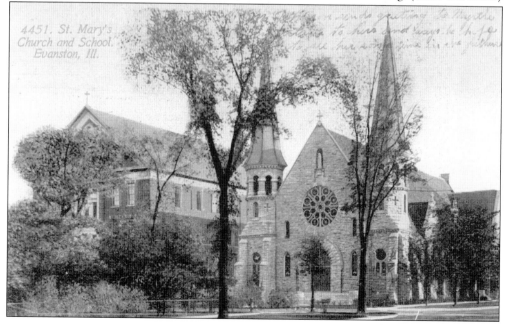

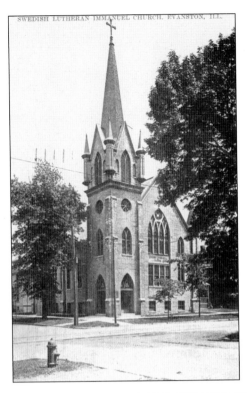

SWEDISH LUTHERAN IMMANUEL CHURCH, 1911. The Swedish Lutheran Church in Evanston was organized on January 10, 1888. The cornerstone of a new building was laid on southeast corner of Sherman Avenue and Lake Street on July 14, 1898. Designed by Henry C. Kroll, the building was constructed of buff brick, trimmed in stone, and had colorful stained-glass windows. This postcard looking east from Lake Street shows the 100-foot tower. The church remains today as the Lutheran Immanuel Church.

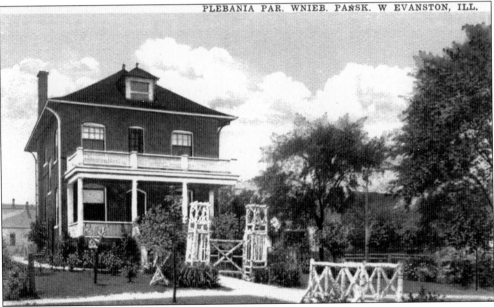

ASCENSION OF OUR LORD RECTORY. This postcard is showing the rectory building of Ascension of Our Lord parish. Around 1910, Polish immigrants began moving to Evanston from Chicago where employment was more suitable and in greater abundance. By 1912, funds were raised and a site was chosen for their own parish church on Wilder Street, between Ashland and Florence Avenues, and construction of Ascension of Our Lord Church began. The construction of the rectory followed in 1913. (CT and PAA.)

112

Eight

OTHER BUILDINGS, STREETS, AND AVENUES

Throughout this chapter of residential streets and avenues of long ago, take note of the lampposts, streetlights, street signs, and hitching posts that are sprinkled in each photograph like a hidden picture book. These postcards are the lasting images of the character-giving qualities that have made Evanston such a special place.

The names of most thoroughfares in Evanston are named in honor of citizens of some early distinction or early local leaders of the Methodist Episcopal Church. There were natural ridges that became Ridge Avenue and Chicago Avenue. Other roads such as Mulford Road and Church and Emerson Streets were created once drainage ditches were excavated. Church Street was named for the first church building located on the street, Mulford Road for pioneer Edward H. Mulford, and Emerson Street after Benjamin Emmerson, who arrived in Ridgeville in 1839, and the Emmerson family farm west of the railroad tracks.

Streets generally run east to west, and avenues run north to south. Main Street and Central Street both seem misnamed but are not really when considering that both were named prior to their annexations to Evanston. Central Street was central to North Evanston. Located in the south end of town, Main Street, formerly Lincoln Avenue, was also known as Evanston Avenue.

As many streets have been left out, the Evanston Public Library has a complete list of all the streets named in Evanston, as does the Evanston History Center. Use this book as an inspiration to learn more about local streets and more about Evanston's past.

This chapter will also show postcards of Evanston and St. Francis Hospitals, which at the time only admitted black people in an emergency. Unfortunately, there are no postcards of the Evanston Sanitarium, which was founded by Dr. Isabella Maude Garnett (1872–1948), a black woman, and her husband, Dr. Arthur Daniel Butler, in their home at 1918 Asbury Avenue in 1914 to serve Evanston's black population. Dr. Butler died in 1924, and Dr. Garnett renamed the institution the Butler Memorial Hospital. The Community Hospital of Evanston was formed and located at 2026 Brown Avenue with Dr. Garnett serving as superintendent of the hospital that served Evanston residents until 1980.

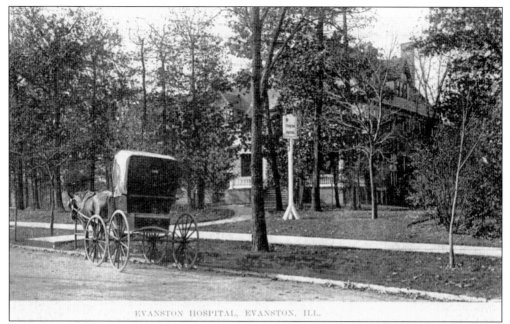

EVANSTON HOSPITAL, EVANSTON, ILL.

EVANSTON HOSPITAL. Sarah B. Blanchard (1837–1907) of the Evanston Benevolent Association organized a meeting at the Avenue House in 1891 where it was decided that an emergency hospital was needed in Evanston. The little hospital with 12 doctors opened on March 27, 1893, at 1107 Emerson Street. After two years, the now renamed Evanston Hospital Association acquired 280 feet on Ridge Avenue north of Central Street for $12,000, and construction on the building began 1897. This card is showing the property on Ridge Avenue with the ambulance donated in 1900 by Grace P. Ewen. Evanston architect George Lyon Harvey (1866–1923), who boasted of hospital expertise, designed the building at 2650 Ridge Avenue, and after several years of fund-raising, it opened on February 8, 1898. In 1914, James A. Patten contributed funds for a new building to be used as a contagious ward, which can be seen on the right in the card below. The cards above and below are postmarked 1910 and 1919, respectively. (S and VOH.)

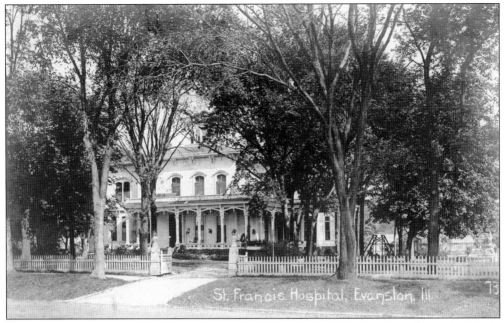

ST. FRANCIS HOSPITAL. In 1867, carpenter James H. Kenny built on the former site of Mulford's Tavern, a house at 365 Ridge Avenue for James Smith Kirk. Peter "Leo" Biermann, pastor of St. Nicholas Roman Catholic Church, and Fr. H. J. Smyth, pastor of St. Mary's Roman Catholic Church, established the St. Francis Hospital Auxiliary Association. On behalf of the Franciscan Sisters, Monsignor Biermann bought the Kirk Homestead and the surrounding 15 acres for $35,000 on December 3, 1900. The house was renovated into a 25-bed hospital. The surrounding property was used as a farm to provide poultry, dairy, and vegetables for hospital use. The card above is postmarked 1906, and the card below shows the proposed rendition of the current building. (CRC and CT.)

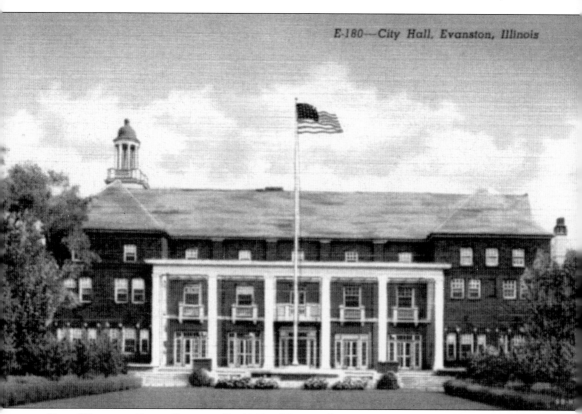

CITY HALL ON LAKE STREET. In 1942, citizens of Evanston voted to issue bonds for the purchase of the Evanston Country Club building on the northeast corner of Lake Street and Oak Avenue. Included in the purchase, the city also acquired land that included tennis courts on the southwest corner of Lake Street and Oak Avenue, property that had been given by Marshall M. Kirkman to the club. The area was turned into a park and named in honor of Clinton Merrick (1886–1944), an alderman who served for 20 years and died suddenly. Following a plan to reorganize Fountain Square into a war memorial, the city did not move into its new municipal building until September 1946, with the dedication held on January 6, 1947. The building was demolished in 1979, when the city moved its offices to the present civic center site, the former Marywood School for Girls. (CT.)

MASONIC TEMPLE. The Masons began meeting in Evanston above a hardware store at 618 Davis Street. In 1870, they moved to 611–613 Davis Street, Dr. Washington S. Scott's new building. In 1909, the Masons were located at 1512 Chicago Avenue until the property was sold to Illinois Bell Telephone Company in 1926. The property at 1453 Maple Avenue was acquired, and Holabird and Roche designed the Masonic temple that is currently on the northeast corner of Lake Street and Maple Avenue. It was dedicated on December 17, 1927. (ECK.)

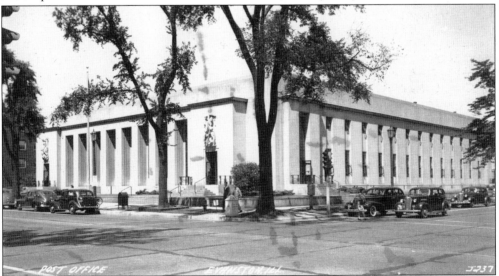

POST OFFICE. During the Great Depression, the federal government selected a new site for the Evanston Post Office at the northwest corner of Davis Street and Oak Avenue. The building was designed by John Carlisle Bollenbacher (1884–1939) and constructed in 1935 from Indiana limestone. The sculptures on the facade and in the lobby were the result of a nationwide competition and relief program for artists sponsored by the government. This card, postmarked 1951, looks northwest, showing the post office at its present-day Davis Street location. (LLC.)

117

DEARBORN OBSERVATORY. The Chicago Astronomical Society constructed an observatory in 1863. J. Young Scammon funded the tower that would house the telescope, in exchange for having the facility named for his deceased wife, Mary Ann Haven Dearborn. On August 10, 1887, the society agreed to bring the telescope to Northwestern University. Designed by Cobb and Frost, the cornerstone was laid for Dearborn Observatory on June 21, 1888. In 1939, the observatory was moved south for construction of the Technological Institute, and in August 1997, a 38-foot aluminum dome was added. This card is postmarked 1941. (CT and JOS.)

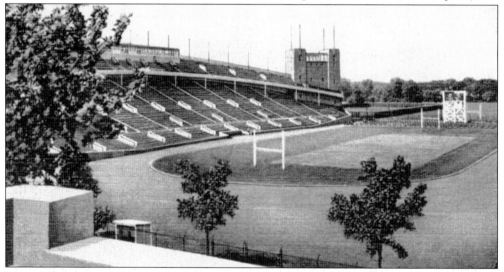

DYCHE STADIUM. William A. Dyche was the business manager for Northwestern University and an Academy alumni, who graduated from the university in 1882. He was a trustee and president of the alumni association. In 1903, he arranged for the construction of Northwestern Field on Central Avenue, 75 feet west of the current stadium. The field had 10,000 seats with wooden stands and served for two decades, until it became clear that larger facilities were needed. The Evanston city council granted permission for construction of a new stadium in December 1925. Work began in 1926 to construct a concrete arena 702 feet long, with curving stands on the east and west sides; the north and south ends behind the goalposts were left open. The seating capacity was over 37,000. The new stadium was named in honor of Dyche. (CT and JOS.)

Headquarters, Rotary International, Evanston, Illinois

ROTARY INTERNATIONAL. On the site of the former Blanchard house, ground was broken at 1600 Ridge Avenue for the Rotary International Building on April 3, 1953. Designed by Maher and McGrew, the 4,800-square-foot building was not large enough, and a three-story addition that provided 27,500 additional square feet was completed in 1966. Rotary moved in 1987 to 1560 Sherman Avenue, and the general board of pension of the United Methodist Church moved into the building. In October 2007, the pension board announced it was moving its offices to Glenview.

NATIONAL FOUNDATION OF FUNERAL SERVICE. In the 1870s, the growing population led to a need for more specialized funeral service. During the 20th century, Evanston was home to a number of places of business that provided training of funeral service industry workers. In 1912, the Casket Manufacturers Association of America was located in Evanston. This postcard shows 1620 Central Street just west of Ashland Avenue where the National Foundation of Funeral Service was located in 1945. (ECK.)

UNIVERSITY PLACE. This real photograph, postmarked 1908, is a rare look at 1833 Orrington Avenue with a view not far from where many years later the street would be closed to make way for Northwestern University dormitories. The view is looking south along Orrington Avenue about one block from Pearsons Hall. (CRC.)

JUDSON AVENUE, SOUTH FROM LAKE STREET. Judson Avenue was named after Philo Judson, an early pioneer. This is another real photograph taken to display the majestic elm trees lining the neighborhood with double rows creating a canopy above. This postcard shows the 1400 block of Judson Avenue looking south. (AJS.)

Forest Ave., South from Greenwood Blvd., Evanston, Ill.

FOREST AVENUE. On this card postmarked 1908 the sender writes, "Evanston is so pretty and the streets here all along have such beautiful Elms. Double rows on both sides." At one time there were so many trees on Forest Avenue people thought that was the reason for its name. However, Forest Avenue was named for its landowner, Thomas L. Forrest. This view of the 1300 block of Forest Avenue was a common sight among many residential streets.

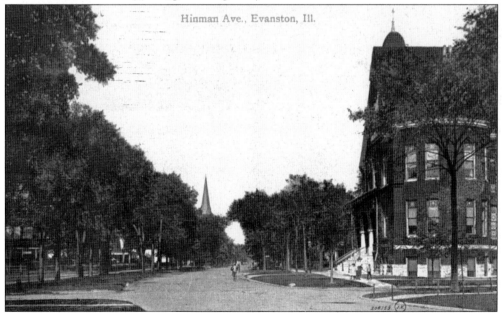

Hinman Ave., Evanston, Ill.

HINMAN AVENUE. This card, postmarked 1910, shows that Hinman Avenue offers more stately elms on the parkway. The view is taken south of Lake Street looking north. The steeple from the First Methodist Episcopal Church is on the left, and the second First Congregational Church building is on the right. (SHK.)

Sheridan Rd. N. from Hamilton St.

122. Evanston, Ill.

HAMILTON AND SHERIDAN. This real photograph, postmarked 1909, was taken from Hamilton Street looking south at the intersection of Hamilton Street and (today) Forest Avenue. The card shows a portion of the house at 1143 Forest Avenue, and it says Sheridan Road north from Hamilton Street. Looking at a 1916 map, the southeast corner was indeed Sheridan Road and Hamilton Street and not yet Forest Avenue. (CRC.)

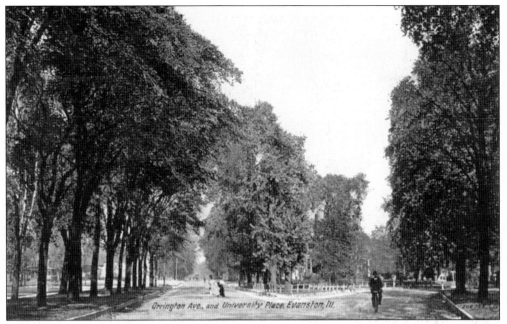

ORRINGTON AVENUE AND UNIVERSITY PLACE. At the time this photograph was taken, Orrington Avenue, University Place, Sheridan Road, and Chicago Avenue formed a large circle. This view, postmarked 1910, taken from north of Clark Street, shows a fork in the road with University Place veering to the right, and Orrington Avenue proceeding north. (V.)

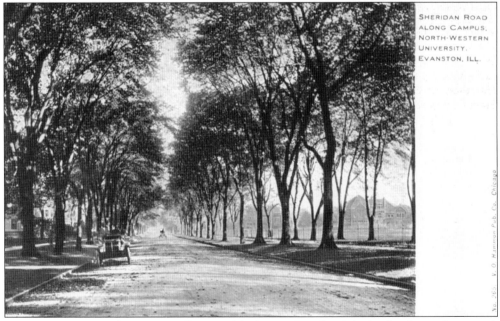

SHERIDAN ROAD. If one was walking and had veered to the right in the above photograph onto University Place, and at the next main road turned left or north onto Sheridan Road, this would be the view awaiting. This picture was taken north of University Place, with Foster Street in the distance. The cathedral-like canopy of elm trees was spectacular and hardly unique. The card is postmarked 1910. (VOH.)

PATTEN RESIDENCE. In 1901, George Washington Maher designed the mansion at 1426 Ridge Avenue for James A. Patten (1852–1928) and his wife, Amanda Louisa Buchanan Patten (1858–1935). Known in Evanston as the "Wheat King," James A. Patten was quite generous to many churches, the YMCA, and Evanston Hospital that he and his wife were involved with. He served as Evanston's mayor from 1901 until 1903. He also served on the board of trustees of Northwestern University from 1917 until 1920. Amanda was vice president of the Evanston Hospital board for almost 30 years and served on the Evanston Township High School board of education. Their home was sold to a developer in 1938 for $50,000 and demolished. (VOH and CRC.)

772 RIDGE AVE. SCENE, EVANSTON, ILL.

RIDGE AVENUE SCENE. But for the historic fence and steps, this scene on Ridge Avenue is nearly unrecognizable, as this postcard is looking north at Lake Street. Due to the number of postcards showing the Patten residence, there is little more of significance to note other than the utter absence of traffic and the noticeable peace and tranquility. (SHK.)

RIDGE AVENUE. This card, postmarked 1914, offers another view looking north on Ridge Avenue from south of Lake Street with the Patten residence on the left. The sender writes, "Martin had a drive on this beautiful road where the trees meet in canopy overhead. Some day we all will live where the trees are abundant." (V.)

125

BIBLIOGRAPHY

Buchbinder-Green, Barbara J. *Evanston a Pictorial History*. First edition. St. Louis: G. Bradley, Incorporated, 1989.

Earhart, Mary. *Frances Willard: From Prayers to Politics*. Chicago: University of Chicago Press, 1944.

Ebner, Michael H. *Creating Chicago's North Shore: a Suburban History*. Chicago and London: University of Chicago Press, 1988.

Fiske, Judy. The Georgian Hotel. National Register of Historic Places nomination. Evanston, 2004.

Foster, Clyde D. *Evanston's Yesterdays*. Evanston: Clyde D. Foster, 1956.

Perkins, Margery B. *Evanstoniana: an Informal History of Evanston and Its Architecture*. First edition. Composed and edited by Barbara J. Buchbinder-Green. Chicago: Chicago Review Press, 1984.

Quaife, Milo M. *The American Lake Series: Lake Michigan*. Edited by Quaife M. Quaife. Indianapolis and New York: the Bobbs-Merrill Company, 1944.

Reeling, Viola Crouch. *Evanston: Its Land and Its People*. Evanston: Fort Dearborn Chapter, Daughters of the American Revolution, 1928.

Reynolds, John. *Pioneer History of Illinois, Containing the Discovery, in 1673, and the History of the Country to the Year Eighteen Hundred and Eighteen, When the State Government Was Organized*. Second edition. Ann Arbor: University Microfilms, 1968.

Scott, Walter Dill. *John Evans: an Appreciation*. St. Charles: Chronicle Company, Inc., 1939.

Smith, Carl. *The Plan of Chicago: Daniel Burnham and the Remaking of the American City*. Chicago and London: the University of Chicago Press, 2006.

Terras, Donald J. *The Grosse Point Lighthouse: Evanston, Illinois*. Evanston: Windy City Press, 1995.

Willard, Frances E. *A Classic Town*. Chicago: Woman's Temperance Association, 1891.

Willard, Frances E. *Writing Out My Heart: Selections from the Journal of Frances E. Willard, 1855-96*. Edited Carolyn De Swarte Gifford. Urbana and Chicago: University of Illinois Press, 1995.

INDEX

ACROSS AMERICA, PEOPLE ARE DISCOVERING SOMETHING WONDERFUL. *THEIR HERITAGE.*

Arcadia Publishing is the leading local history publisher in the United States. With more than 3,000 titles in print and hundreds of new titles released every year, Arcadia has extensive specialized experience chronicling the history of communities and celebrating America's hidden stories, bringing to life the people, places, and events from the past. To discover the history of other communities across the nation, please visit:

www.arcadiapublishing.com

Customized search tools allow you to find regional history books about the town where you grew up, the cities where your friends and family live, the town where your parents met, or even that retirement spot you've been dreaming about.